DONALD SULTAN

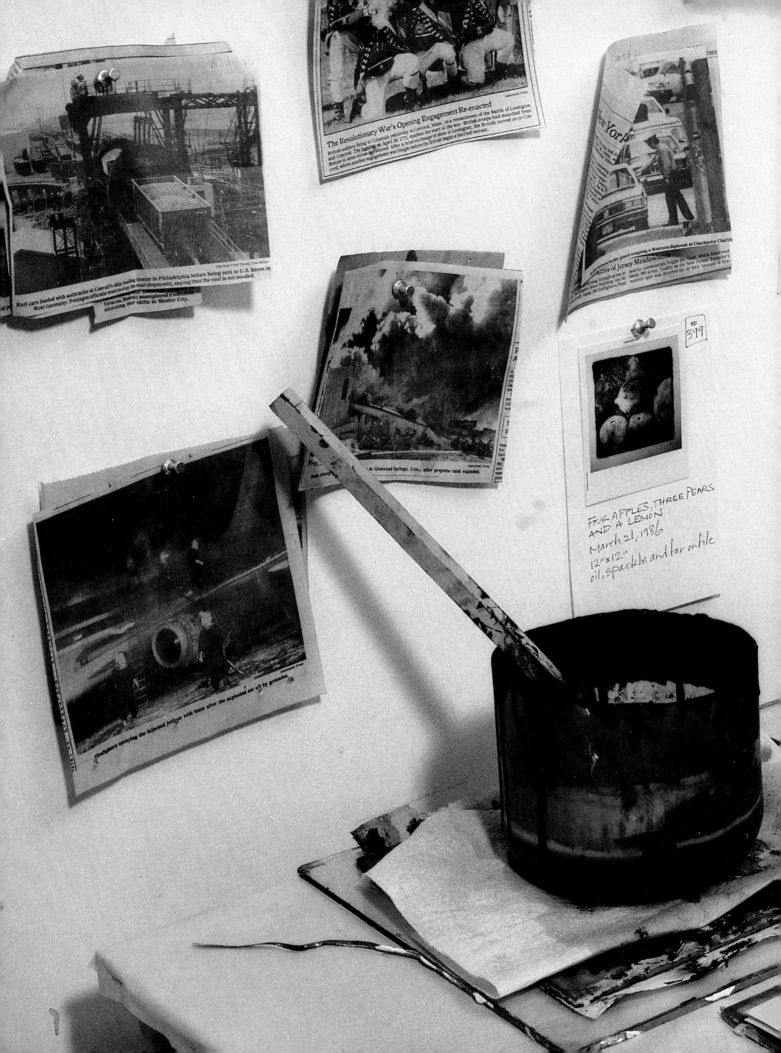

DONALD SULTAN

MUSEUM OF CONTEMPORARY ART
CHICAGO

HARRY N. ABRAMS, INC.
NEW YORK

This publication accompanies the exhibition "Donald Sultan"
organized by the Museum of Contemporary Art, Chicago

TOUR SCHEDULE:
Museum of Contemporary Art, Chicago
September 12 through November 8, 1987

Museum of Contemporary Art, Los Angeles
November 24, 1987, through January 10, 1988

Fort Worth Art Museum, Texas
January 24 through March 20, 1988

The Brooklyn Museum, New York
April 9 through June 13, 1988

FRONT COVER:
Lemons April 9, 1984. Collection Roger Davidson, Toronto
BACK COVER:
Firemen March 6, 1985. Museum of Fine Arts, Boston
PAGE ONE:
Donald Sultan, New York, 1986

EDITOR: Terry A. Neff, T. A. Neff Associates, Chicago
DESIGNER: Judith Michael

LIBRARY OF CONGRESS CATALOGING-IN-PUBLICATION DATA

Sultan, Donald.
Donald Sultan.

Catalog of an exhibition held at the Chicago Museum of
Contemporary Art.
 Bibliography: p. 104
 Contents: Donald Sultan / by Ian Dunlop—Donald
Sultan, contemporary art, and popular culture / by Lynne
Warren.
 1. Sultan, Donald—Exhibitions. I. Dunlop, Ian,
1925- . II. Warren, Lynne. III. Museum of
Contemporary Art (Chicago, Ill.). IV. Title.
N6537.S92A4 1987 709'.2'4 86–32051
ISBN 0–8109–1513–8
ISBN 0–933856–26–1 (Museum: pbk.)

TIMES MIRROR BOOKS

Printed and bound in Japan

CONTENTS

FOREWORD

Donald Sultan's generation of artists grew up when geometric abstraction was the dominant style. This inheritance is faintly echoed in Sultan's paintings by the underlying gridwork provided by the tiles and by the sense of flatness resulting from the silhouetting of shapes and the materiality of the tarred surface.

What is important in Sultan's work is how he found his own way to move beyond the dominant aesthetic with which he grew up. This he did, and continues to do, through a refreshing amalgam of sources as disparate as Baroque and Impressionist painting, Abstract Expressionism, and geometric abstraction. His repertory of images ranges from those as traditional as still life to others as specifically American as a "rust belt" cityscape. Also distinctive are sharp figure/ground contrasts; the exquisitely wrought silhouetted shapes, whether or not they portray immediately recognizable objects, often contrast boldly with an atmospheric envelope.

The Museum of Contemporary Art is pleased to present in this exhibition and book the first in-depth look at these remarkable paintings and drawings. Thanks are due to Lynne Warren for her sensitive and thoughtful curating of this exhibition. Her essay and Ian Dunlop's will provide great rewards for both those new to Sultan's art and those who have already had occasion to enjoy his work. We deeply appreciate the support of the Board of Trustees and the Exhibitions Committee of the Museum of

Contemporary Art and also the hard work on the part of the MCA staff in bringing this project to fruition. In particular I wish to thank Lela Hersh, registrar, and Geoff Grove, head preparator, for their expert handling of the details of organization and the works themselves; Robert M. Tilendis, executive secretary, for the various aspects of his work on this publication; and Peter Doroshenko and Kathryn Hixson, museum interns, for their substantial research on Donald Sultan's career. Sincere thanks also to Terry A. Neff of T. A. Neff Associates for her careful editing of this book, and to Margaret L. Kaplan of Harry N. Abrams, Inc., for working with us on this copublishing venture.

To the generous lenders who have made the traveling exhibition possible, and to Blum Helman Gallery, New York, for its many courtesies, we are most grateful. We acknowledge with pleasure the financial support of the National Endowment for the Arts, a federal agency, and the Illinois Arts Council, a state agency. Thanks also to my colleagues who are presenting this exhibition at their institutions. For Donald Sultan's enthusiasm, patience, and willing participation in both the exhibition and book, our deep thanks, and our congratulations to him for making these wonderful works of art which it is our pleasure to present to our visitors.

I. MICHAEL DANOFF
Director

DONALD SULTAN

BY IAN DUNLOP

For Donald Sultan painting seems to be a
continual adventure. He has no sooner completed
enough paintings to make an exhibition than he
begins on the next one. In his studio four or five
eight-foot-square paintings hang in varying states
of progress. Other panels covered in a thick
black tar are laid out ready to be worked on. The
room looks more like a well-ordered workshop
than a studio. If Sultan has to leave New York
for any length of time, he likes to have on hand
at least one half-completed picture. He compares
painting to playing the piano — it helps to be in
practice. Besides, there is the mystery of where
the next work will take him. "I am just
compelled to keep going," Sultan says. "I want to
see where the paintings go. I am fascinated by
their progression."* Then, looking over to a
small still life hanging next to a much earlier
painting from 1979 of New York buildings, he
adds, "I love looking at this little 'building
canyon' next to the lemons and the egg and
seeing how similar they are."

A similar compulsion seems to grip him when
talking about his paintings or about art in
general. Expressed in a soft, Southern cadence,
words, ideas, opinions tumble forth, sometimes
sharp and to the point, often tinged with irony,
occasionally yielding sentences which are hard to
follow. While many artists are racked with doubt

*This and the quotations from the artist that follow are taken from
conversations with the artist in New York in the spring of 1986. This
essay was completed in June of that year.

when away from the studio, or even when standing before a finished picture, Sultan radiates self-confidence; he clearly loves his paintings, is proud of them, and does not care who knows it. In his mind's eye new paintings are in a continuous state of formulation and he can hardly wait to try out some variation on a past theme or begin a fresh subject. Only the slow and methodical way his pictures are prepared keeps his output in check and limits him to about fifteen or sixteen large pictures in a year. His pictorial energy finds release in drawings, prints, small pictures like the recent spate of still lifes. Of his fecundity he says with engaging frankness, "I feel I am on a roll."

Energy and ambition alone would amount to very little if Sultan did not possess a wide stock of pictorial ideas. In fact, the whole world around him provides him with subjects. From the industrial landscape he has garnered images of chimney stacks and street lamps; from newspapers, photographs of fires, explosions, and airplane crashes; and from nature, the shapes of fruits and flowers, and indirectly the form of the human body. As a result, Sultan is one of the few artists active today who could be said to paint "modern life," the world of common objects and shared experiences which gives life today its edge or taste and distinguishes it from what has gone before. But his "modernness" is not just a matter of subject matter, of depicting topical events clipped from the newspapers. It is rooted instead in the means by which his pictures are produced and the way his compositions are formed. His modernness exists at three levels: on the visual and stylistic level, in his use of nonart materials, and in his sources and choice of subjects.

I SULTAN'S VISUAL STYLE

Sultan's paintings of the last five or six years tend to fall into two groups: the first group consists of bold, brightly colored pictures with

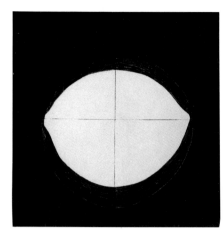

FIG. 1
Lemon Nov. 28, 1983
Oil, plaster, latex paint, and tar
on vinyl composite tile
on Masonite
244 × 244 cm (96 × 96 in.)
Eli Broad Family Foundation,
Los Angeles

well-defined shapes and crisp outlines forming a clear silhouette; the second group consists of dark, hard-to-read pictures full of menace and often inspired by disastrous industrial events such as warehouse fires, airplane crashes, and freight train derailments. In both cases the pictures make a strong, immediate visual statement. As in an abstract picture, the viewer's eye is quickly caught by shapes, colors, and patterns; that first glance produces the first visual pleasure. A painting such as *Lemon Nov. 28, 1983* (fig. 1) — the start of a whole series of lemon pictures and one of the boldest — depends for its effect almost entirely on the elements of shape and color. The fruit occupies a dominant central position, spreading itself across all four panels of the painting. A faint, scratched halo around the fruit conveys the form of a plate on which it rests. Sultan's lemon is more an ideogram than an actual physical object; its outline could also be that of a kind of gigantic eye-socket. But the real power of the painting comes from the contrast between the pulsating, bright acid-yellow color of the lemon and the pitch-black background. There are equally bold visual effects in a series of pictures of smokestacks, where the chimneys are restricted to simple tubular forms and colors are introduced into the plumes of smoke or fire coming out of their tops — "industrial flowers," he calls them — or they can be found in a one-of-a-kind work like *Equestrian Painting Feb. 15, 1983* (fig. 2), where a splash of red is silhouetted against a black background.

In the dark pictures, those inspired by industrial disasters, color plays a less important part and the paintings depend for their effect on patterns of light and dark patches, rhythmic arrangements of black and white lines, and thick, blistered surfaces. *Lines Down Nov. 11, 1985* (fig. 3), inspired by a guerrilla bombing of electrical power lines, consists of intersecting black lines suspended between two large black masses placed on either side of the picture. This

is classic American picture-making in a tradition that goes back to Jackson Pollock.

Donald Sultan grew up at a time when abstraction seemed the only path forward in American painting. There was expressionist abstraction, with Pollock as the beacon, and there was geometric or minimal abstraction, spearheaded by Barnett Newman. Sultan has been affected by both. He first became aware of Pollock while growing up as a child in Asheville, North Carolina. He remembers his father, who painted in the time spared from his tire business, working flat like Pollock but with canvas placed on a table rather than the floor. Later, at The School of the Art Institute of Chicago, Sultan for a time worked in a similar fashion, pouring plastic paint onto canvases and·throwing onto the surface bottle caps, bits of wood, and other debris. At the same time he became aware of the power of abstract shapes; some of his first paintings done after leaving the School show his attempts to reduce complex objects from the real world down to simple, geometric shapes (see fig. 4). A few small paintings kept in the studio—like those of a gun (fig. 5)—stand as reminders of these early endeavors.

In the process of translating things from the real world, Sultan discovered the joy of

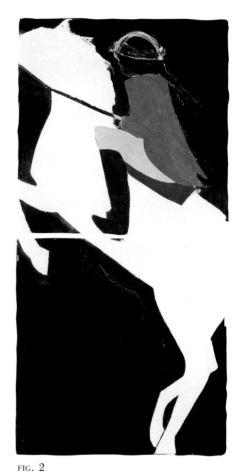

FIG. 2
Equestrian Painting Feb. 15, 1983
Tar, plaster, chalk, and latex paint on vinyl composite tile on wood
247.7 × 123.8 cm (97¹/₂ × 48³/₄ in.)
Private collection, New York

FIG. 3
Lines Down Nov. 11, 1985
Latex paint and tar on vinyl composite tile on Masonite
243.8 × 245 cm (96 × 96¹/₂ in.)
Private collection, New York

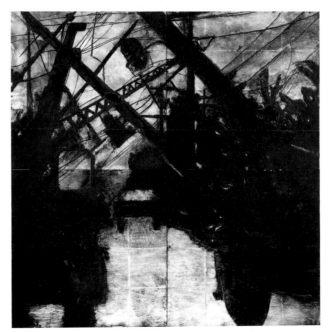

FIG. 4
December 7, 1978
Tar on vinyl composite tile on wood
30.5 × 30.5 cm (12 × 12 in.)
Private collection, New York

FIG. 5
Black Gun March 18, 1982
White Gun March 18, 1982
Two panels; graphite on vinyl
composite tile on wood
Each 30.5 × 30.5 cm (12 × 12 in.)
Private collections, New York

ambiguity: images could take on more than one meaning. The lemon could be an eye-socket, smokestacks could be the stems of flowers, street lamps could suggest tulips, a MiG airplane could look like a fish. Behind many of these images, there are barely disguised erotic associations. It requires no Freudian genius, for example, to see the outline of a female breast and nipple in his paintings and drawings of lemons, or the suggestion of buttocks and thighs in some of the delightful small still lifes of pears and nectarines. The tulip drawings are full of erotic associations. The bending stems and the outline of the petals can be read in a number of ways. Sometimes the female form is found not in the flower itself, but in the white paper left untouched by the charcoal. Sultan creates the same kind of positive/negative illusion in the large paintings of flowers and vases where the outline of the vase leaves the shape of the breasts and chest in the black background.

Sultan is an unabashed eroticist. "I think all great paintings are sexy," he says. But he has avoided the use of explicit imagery in favor of images that work by association. In common with some of the more clever forms of advertising, he has used images that stand for tangible goods and are also symbols which work on the subliminal mind. The visual style of his pictures is thus linked to the way we experience images through magazines, billboards, and other forms of media. It is these "links," and Sultan's ability to find images with multiple meanings, which are alternately abstract and concrete, that make his work visually modern.

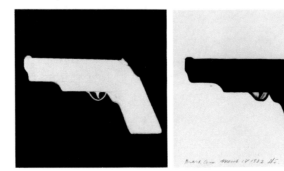

II SULTAN'S MATERIALS

In addition to his style, the most noticeable way
in which Sultan's work looks modern is in the
materials he uses. Some time ago, by process of
trial and error, Sultan developed a novel method
for constructing pictures. First he takes standard
four-foot-long wooden stretcher bars and makes a
square. Then, using three-inch-long steel rods,
he bolts a four-foot-square sheet of plywood to
the stretchers. Next he adds a layer of Masonite
onto which he glues standard, twelve-inch-square
vinyl tiles — the green and blue ones with flecks
of white which grace office and factory floors the
world over. Finally he applies a thick layer of
butyl rubber — the stuff used in roofing. It sounds
complicated and, indeed, the preparation of
Sultan's basic picture module is a slow process
requiring the help of more than one assistant.
But once enough of the basic four-foot-square
units have been completed, they can be
combined in groups of two to form a diptych
measuring eight feet by four, or in groups of four
to create what is, at present, his preferred
picture size of eight feet square.

The butyl material which forms the outer skin
of his pictures has a distinctive and attractive
quality of its own and offers the artist a number
of advantages. For one, the amalgam forms a
loose, but definite, framing edge to his pictures.
Secondly, the matte-black material exerts a
strong physical presence. It is a positive, rather
than the usual negative force, so that when one
looks at the black surface, the spectator does not
feel as though he is looking into empty space.
When color is added, say the bright yellow of a
lemon or the orange of a flame, the result is a
rich mixture of opposing forces, with the colors
appearing to come out at the spectator and then
recede into the black background; simultaneously
the black surface also appears to advance and
recede. In many ways the effect is like Hans
Hofmann's old push-pull theory of color in a new
form. Thirdly, the black surface provides a kind

of empty slate on which the artist is able to try out his ideas and refine his images. He can outline his subject matter in chalk, work out his basic shapes and masses, and adjust their position. Then, when the composition has reached a more or less final form, the tar or butyl is cut and scraped away down to the tile backing. In some cases, notably the fire pictures, the surface is burned away with a blowtorch and the tar peels into globules and blisters. It is with some justification that Sultan claims he has replaced the traditional artist's tools of pencil and brush with industrial tools such as the knife and the blowtorch. He clearly enjoys the process of working the tar, the cutting and burning. "I like drawing with a knife," he says. "I like cutting through the surface, working into and not on it, and the physical part of it."

After the cutting and the burning have been completed, Sultan often uses plaster to build the surface up again. Color is added, applied with a sponge or rag. In the early works the color was laid on flat and even, but in recent paintings Sultan has placed more emphasis on modeling, giving his pictures an added richness. Sometimes the vinyl tiles are left exposed and their inherent color is incorporated into the meaning of the picture. In *Cantaloupe Pickers Oct. 1, 1983* (pl. 5), for example, the green-flecked vinyl stands for the fields in which the laborers are working. For all the heavy physical effort involved in preparing and completing his pictures, Sultan's work does not look labored or forced; his materials do not dominate the content of his pictures. There is an easy harmony between the two, and the more pictures he produces, the more fluent his technique seems to become. For while the first tar and vinyl tile pictures contain fairly simple geometric shapes, recent works manifest more lifelike forms, the colors have become richer, and the modeling is more pronounced.

When asked how he came to invent his methods, Sultan replies that he was searching for

a way to paint that has physicality and weight, and one chance discovery led to the next. Undoubtedly his early experience in freelance construction work and his familiarity with builders' tools and methods helped. He is also a natural improviser — a capability that stood him in good stead when he experienced dissatisfaction with traditional painting techniques while at art school. It is worth noting that before studying painting at The School of the Art Institute of Chicago, Sultan had been involved with acting and scenery painting; subsequently he concentrated fully on painting. An exhibition of Marcel Duchamp's work at the Art Institute helped point the way out of traditional painting techniques. When the enigmatic Duchamp was asked why he abandoned oil and canvas to work on glass, he replied he was tired of filling in the backgrounds of his canvases. This seemingly flippant remark struck a responsive chord in Sultan, who felt a similar impatience with the problem of figure and ground. Filling in backgrounds is "just busy work," he says, and a waste of the artist's time.

Duchamp's ironic stance, his ability to cast doubt on traditional beliefs about art in general and painting in particular, had a wide influence on artists in the 1960s and into the 1970s, reaching such disparate figures as Jasper Johns and Andy Warhol. Sultan, who delights in pictorial and visual puns, was also affected. In the process of developing his use of nonart materials, he was delighted to find that many of his techniques are visual metaphors for his subject matter. Sultan enjoys the fact that his forest fires and poisonous gas fumes, his burning buildings and scorched landscapes, are created by fire and smoke in the studio. His oil pumps stand as a reminder of the crude oil from which his linoleum and butyl rubber are derived. His pictures of warehouses and factories are made from factory materials. "I like the idea of using materials as if they were paint and using paint like industrial materials," he says. "It is another

flip." His love of irony also extends to his choice of titles. A recent work called *Plant May 29, 1985* (pl. 17), for example, refers not to some living organism, but to an abandoned steel mill left to the weeds and to rust.

However, these verbal and visual puns should not be taken too seriously. There is a deeper purpose behind Sultan's choice of materials — the desire to produce pictures that can stand as both physical objects and independent works of art. It is their physical nature that is important to him and not the materials from which they are made. "There is nothing in painting that hasn't been tried," he points out. "People painted on everything. And I think a da Vinci painting on the wall — painted into the wet plaster — is no less interesting than the ones on wood and canvas. It has to do with what you are doing." But for all Sultan's no-nonsense attitude toward the physical nature of his pictures, he certainly wants people to know they are "art." "If someone were to find one of my works lying in the street," he once remarked, "I would want them to know it is a work of art and not some piece of scrap material thrown out by a builder."

III SULTAN'S SOURCES AND SUBJECTS

Despite his commitment to modern materials and modern ways of seeing, Sultan is not unaware of the tradition of modern art and its roots in the nineteenth century. He enjoys looking at paintings by Old and Modern Masters, learning from them, finding inspiration in their pictorial examples, and adapting his discoveries to his own way of seeing. In this respect there are a number of interesting parallels between his work and the paintings of Edouard Manet, not only because a number of his paintings refer to canvases by Manet — the small still lifes Manet used to give to his friends (see fig. 6), a nighttime view of Boulogne harbor (see fig. 7), and *The Execution of Emperor Maximilian of Mexico* (fig. 8) — but also because he seems

FIG. 6
Edouard Manet (French, 1832–1883)
Lemon, 1880–81
Oil on canvas
Musée d'Orsay, Paris

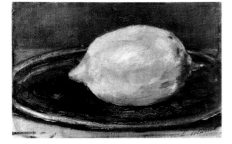

formed in the Manet mold, with a similar desire
to succeed, to win acceptance, and a similar
compulsion to paint "modern life." Like Manet,
Sultan is fascinated with modern times and the
world around him, and is often stimulated by
news events, although in Sultan's case these
events are airplane crashes, industrial fires, and
gas leaks. Again like Manet, Sultan has found
inspiration in the art of the Old Masters: in
Manet's case with Velázquez and Frans Hals; for
Sultan, Zurbarán, Velázquez, Goya, Monet, and
a host of other artists. Like Manet, Sultan
reworks traditional themes in a modern manner
and finds a personal solution to ancient problems
that reflects his own time. But there are
differences. While Manet was content to paint
the world of nineteenth-century Paris using
traditional means of oil and turpentine, brush
and canvas, Sultan uses tar, vinyl floor tile, and
plaster. And although the parallels between
Sultan and Manet are considerable, the history of
art continues to provide Sultan with fresh
inspirations: Gustave Caillebotte, Winslow
Homer, Edvard Munch, and Edward Hopper, for
example. Yet ultimately Sultan's own painting
still furnishes the main starting point for new
work and is the primary source material for his
restless, image-hungry mind.

The brief decade that to date encompasses
Sultan's mature work has witnessed his
exploration of a considerable range of subjects —
forest fires, cantaloupe pickers, oil pumps, a
battleship with guns blazing, an equestrian,
steers, and lemon still lifes. Many of his most
striking images derive from the industrial
landscape: a series of paintings of smokestacks
and another on the motif of the standard New
York street lamp. These are highly stylized
paintings, beautiful and decorative, and out of
them stemmed Sultan's interest in flowers, tulips
and irises in particular, which began to appear in
large, elegant, black-and-white charcoal
drawings. He then turned to painting more still
lifes, using mainly lemons, but also adding other

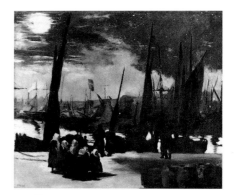

FIG. 7
Edouard Manet
Moonlight over Boulogne Harbor, 1869
Oil on canvas
Musée d'Orsay, Paris

FIG. 8
Edouard Manet
*The Execution of Emperor Maximilian
of Mexico*, 1867
Oil on linen
Städtische Kunsthalle, Mannheim,
Federal Republic of Germany

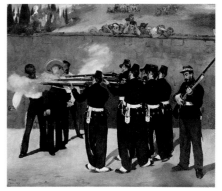

17

fruit and then eggs. But his interest in the industrial landscape remained; he began to paint nocturnal scenes in which industrial buildings and machinery are depicted in a dark and menacing light, often at the point of being consumed by fire and smoke.

Among the first pictures in the series was *Harbor July 6, 1984* (pl. 10), inspired by Manet's *Moonlight over Boulogne Harbor*, which caught Sultan's eye in the great Manet exhibition at The Metropolitan Museum of Art, New York, in 1983. Sultan then reused a section of his *Harbor* picture in *Poison Nocturne Jan. 31, 1985* (pl. 12), a work suggested by a news report of a gas spill in New Jersey; the accompanying grainy photograph of the scene of the accident in *The New York Times* shows a heavy, steel-girded bridge spanning a stretch of river in the industrial wasteland between Newark and New York. Just over a month later, Sultan completed the first of many factory fire pictures, *Firemen March 6, 1985* (pl. 14), showing three firemen silhouetted against the flames pouring from a burning warehouse. In their helmets and overcoats, the figures look like seamen in a Winslow Homer.

Firemen marked the beginning of a whole series of what Sultan calls "event" pictures, which are largely inspired by photographs clipped from the newspapers (see fig. 9): a plane crash, a riot, a train derailment, more industrial fires, and an abandoned steel mill. Sultan views these brooding pictures as his attempt to illustrate the frailty of human endeavor, but without his taking a moralizing stance. He does not like "storytelling" or "didactic painting." He believes, "The quality of a painting is constantly to advise and dissent. A person brings to painting his own set of perceptions and it is the painting's job to bring about a continual dialogue with those perceptions — no matter at what level they may be. . . . You have to engage people, and let *them* fill in the [meaning of the] picture." Although Sultan likes to maintain that he is

attracted to news events because of the pictorial possibilities to which they give rise (pointing to the visual drama of criss-crossing lines in *Lines Down Nov. 11, 1985* (fig. 3), he will admit to a political point of view which is left of center and to a fascination with what he calls "the clash between nature and industry." Enormous claims are made for today's products of labor, he points out, but there are always failures. The 1986 disaster in the Soviet Union at Chernobyl and the terrible loss in the United States of the space shuttle might have provided a subject for paintings but, not without good reason, Sultan regards these events as too obvious and too loaded. Besides, in regard to Chernobyl, the feeling of the invisible menace of radioactive clouds is conveyed in *Battery May 5, 1986* (pl. 21), in which the glowing, dirty yellow sky suggests that some explosion or fire has taken place over the horizon.

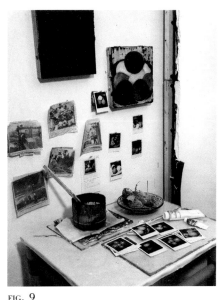

FIG. 9
Donald Sultan's studio, New York, 1986

In common with many artists of our time—Jasper Johns, Frank Stella, Roy Lichtenstein, Andy Warhol, to name a few—Sultan's subject matter, even when dealing with current events, is also about art itself. In Sultan's case he is concerned not so much with artistic style but with specific paintings that have caught his eye. Many have a Spanish origin: a Zurbarán still life was a partial inspiration for the first lemon picture; a Velázquez prompted the equestrian painting. But French paintings have also suggested pictures and themes: Monet's poplar trees lie buried in Sultan's smokestacks; Manet's small still lifes were an additional source for Sultan's first lemon picture. American artists have also left their mark: a Whistler Nocturne helped inspire *Poison Nocturne* (pl. 12); there is an echo of Sheeler or Demuth in the pictures of watertowers, smokestacks, and factory buildings. Sultan's use of paintings by Old and Modern Masters is never immediately apparent, however, and the references may come to light only after the picture has been completed. Seldom are there any direct quotations, as in Lichtenstein's

19

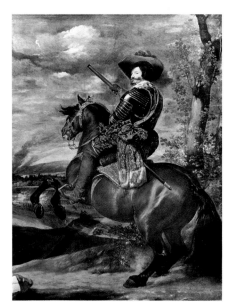

parodies of Matisse, Picasso, and the Abstract Expressionists, nor does Sultan make literal transformations of famous Old Master subjects into modern dress. Rather, Sultan absorbs famous images into his own pictorial thinking; the sources become one element among many in his production of a new work. Three recent paintings provide interesting insights into Sultan's creative process.

Equestrian Painting Feb. 15, 1983 (fig. 2) was in part inspired by Velázquez's *Conde de Olivares on Horseback* (fig. 10), which Sultan saw on a visit to the Museo del Prado in Madrid. He posed himself the question of how a traditional heroic theme of horse and rider could be painted today in a way that made sense. Two obvious solutions would be a picture based on the "Marlboro Man"—the mustachioed, denimed cowboy in the cigarette ads—or an image from a sports magazine. Sultan selected the second alternative, using a picture of a Lippizaner stallion being put through his paces. He created the painting on two panels in which all the modeling of the original image has been flattened; the horse is reduced to a bare white silhouette and the rider to patches of red, beige, and black. Sultan cleverly conveyed movement in the picture by using the framing edge to cut off the horse's nose and tail, suggesting that the animal is about to leap out of the picture altogether. By the time Sultan was finished, the original Velázquez was only a faint memory.

In another dramatic painting from the same year, *Battleship July 12, 1983* (fig. 11), the reference to a famous Spanish masterpiece is even less evident. Here heavy guns, silhouetted against a night sky, are being fired and bright orange flames leap from their muzzles. The date of the picture refers to the day the work was deemed finished and not to an event that took place that day. As it happened, guns similar to the ones in Sultan's picture were in use in February 1984 off the coast of Lebanon when a U.S. battleship opened fire on what were

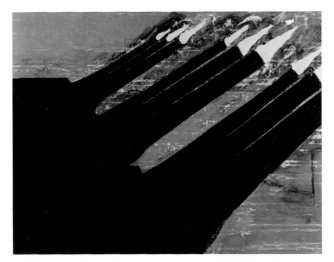

FIG. 11
Battleship July 12, 1983
Oil, watercolor, plaster,
and tar on vinyl composite
tile on Masonite
182.8 × 243.8 cm
(72 × 96 in.)
Eli Broad Family
Foundation, Los Angeles

regarded as hostile positions in the Lebanese
hills. Coincidence, but not entirely. Back in
1983 Sultan had clipped a photograph of a U.S.
battleship of World War II taken out of mothballs
and brought back into active service. The old
guns were fired; it became almost inevitable that
once they had been used in practice, they would
be used for real.

The photograph was, however, only one source
for the painting. Sultan's earlier pictures of
smokestacks with flame burn-offs, turned on their
sides, produced the image of guns firing. Yet
another source was Manet's *The Execution of
Emperor Maximilian of Mexico* (fig. 8), which
shows soldiers firing at the luckless ruler of
Mexico. Finally, behind this picture lay Goya's
masterpiece *The Third of May* (fig. 12), which
impressed Manet when he visited the Prado in
the 1860s and Sultan in 1983.

Neither the Goya nor the Manet could be said
to have influenced the pictorial structure of
Sultan's painting, but they have left some mark
on the content. All three pictures deal with
warfare; if placed side by side, they would make
an interesting comment on the way warfare has
changed in the last 150 years, a point that has
not escaped Sultan. In the Goya the eye is
caught by the victims, the heroic revolutionaries
who, in one last desperate gesture, throw open
their arms in the face of the firing soldiers. In
the Manet the emphasis falls on the soldiers in
their uniforms and regimented stance, packed

FIG. 12
Francisco de Goya
(Spanish, 1746–1828)
The Third of May, 1808
Oil on canvas
Museo del Prado, Madrid

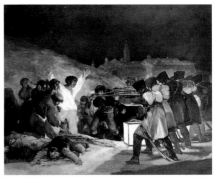

shoulder to shoulder and allowing little room for individuality or personal feelings. The victim, the poor emperor, is a shadowy figure in the background. In Sultan's picture the victims have disappeared altogether—nameless and faceless figures existing by implication miles away from the huge battleship guns. All we see are the weapons of modern warfare, not even the people who man them. We are reminded of the dangers of modern technology, the impersonality of modern warfare. There is a message in this picture, but it is not one the artist states explicitly. He leaves the viewer to come to his own conclusions and, if he sees fit, to make the connections to the Manet and the Goya.

Sultan leaves the same freedom to the viewer confronting the recent painting *Battery May 5, 1986* (pl. 21). The painting is a mystery. In part inspired by a news photograph of strollers on a winter promenade in Battery Park, it is oddly reminiscent of Gustave Caillebotte's city views in which the nineteenth-century French artist made dramatic use of steep perspective. Through color, perspective, and mood, Sultan has suggested some unseen menace beneath an innocent vignette of lovers and children out for a stroll.

Battleship, Battery, and the string of event pictures clearly establish the fact that Sultan is an avid reader of newspapers and that news photographs have provided a useful source for subjects. It is also evident that his own paintings have been a constant source of inspiration for new work. But of equal importance of late has been a stack of Polaroid photographs of still lifes of fruit and flowers, kept at hand in the studio. Beginning with the lemon painting of 1983, still life has come to play an increasingly important part in Sultan's subject matter. As mentioned earlier, the first painting of a lemon was confrontational and very abstract. Since then, the still lifes have become more complex and richer in technique and meaning. The shape of the plate on which the lemon rests, only a faint halo in the first picture, has become more

pronounced; the modeling has become stronger and more three-dimensional; and the colors have become less flat and more varied. The fruits have also proliferated — the lemons have been joined by pears, oranges, apples, nectarines, and even eggs. In some instances Sultan has introduced black lemons and black eggs — not for symbolic reasons but as a pictorial device, a way of injecting something different into the standard still life. "I wanted to introduce something black into all the lushness," explains Sultan, "something that could be a hole and a volume at the same time. To have weight pressing on the lushness of the other fruit. To introduce a mysterious quality. To make the still life into something industrial, weighty."

Just what Sultan is getting at is not always easy to follow, but it is clear that the large still lifes have more in common with the event paintings than might at first be apparent. These are not exactly odes to the joy of life and the wonder of fertility. They have a dark, brooding quality which suggests Sultan has more of a Romantic sensibility than he would be prepared to admit.

For true pleasure and unabashed eroticism, the viewer is better advised to turn to the small still lifes, measuring about twelve inches square. In these pictures Sultan is at his most spontaneous. Here he seems to feel free to experiment with different shapes and colors, to be more painterly and less graphic. The result has been a series of delightful and rich pictures of fruit that have the intensity of medieval stained glass (see pls. 9, 11, 13, 15, 18, 19).

Running parallel with these still lifes are a small number of large, eight-foot-square paintings of flowers and vases, the first of which was completed in January 1985 (fig. 13). Flowers have been a running theme in Sultan's output. He regards as his first flowers the chimney stacks which, looked at in abstract light, could be said to depict a kind of industrial flower. Later, when he was painting his tulips, the way in which the

head of the flower bends down from its stem reminded Sultan of the curving form of street lamps. He began to explore the graphic possibilities of this ambiguous formal relationship in a series of large, handsome flower drawings on big sheets of paper using mainly charcoal but occasionally, in the iris drawings, adding a touch of yellow. Although the image of his flowers derived from industry, clearly the female form played a large role in the inspiration behind these shapes.

For the most part Sultan kept to single flower specimens, but in the 1985 painting mentioned above, he decided to do something a bit more ambitious and put several flowers of different species in a vase. In this work and in subsequent flower pictures, the top half of the painting is devoted to a mass of bouquets, leaves, and sprigs of greenery; the bottom half is given over to the vase, a relatively small one in *Flowers and Vase Jan. 24, 1985* (fig. 13) and a big, bulky one in *Flowers and Vase Aug. 12, 1985* (Collection Ronald Greenberg, Saint Louis). The reason for this division also makes a connection between these paintings and the rest of Sultan's work. "They are different ways of looking at disintegration," he says. "The flowers are spontaneous, like fires in a way. The way they are drawn into a painting — the way they flop, they look ugly — look chaotic in the bowl. The bowl is the structure."

Painting flowers in a vase can easily seem too pretty and too seductive. Sultan explores ways of avoiding these pitfalls: making the flowers messy and restricting the colors to darker tones, or removing color from the picture altogether. In *Tulips and Vase June 2, 1986* (pl. 22), he has returned once again to tulips, cutting out their shapes from the black tar and filling in the gaps with white plaster. The result is a picture that looks as though it had been made with scissors from pieces of black and white paper. Interestingly, the picture was in part inspired by a Matisse — not a Matisse cut-out, but a section

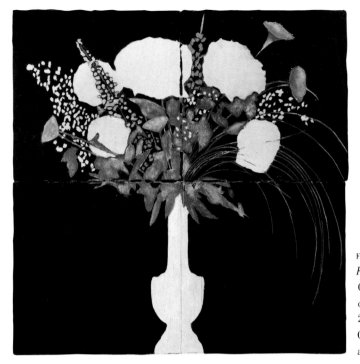

FIG. 13
Flowers and Vase Jan. 24, 1985
Oil, plaster, and tar on vinyl
composite tile on Masonite
246.4 × 246.4 cm (97 × 97 in.)
Collection Brooke Hayward
and Peter Duchin, New York

of a still life in the Philadelphia Museum of Art. *Tulips and Vase* is one of Sultan's most dazzling and most successful flower paintings to date. A new painting, a fresh variation on a past theme, may already be taking shape in the artist's mind. The adventure is ongoing.

Where next? Where will the adventure take us? It might seem foolish to make predictions. But in Sultan's case we are able to look at what he has achieved over the last ten years and, with that information, we have some signposts to the future. His great strength has been his ability to produce paintings that succeed on a number of different levels and that possess a number of different meanings. Paintings such as *Battleship, Equestrian Painting, Lines Down,* and *Firemen* are big, ambitious pictures that work visually, are well made, and contain multiple meanings and associations. Despite the fact that some of their references are topical, they will not easily become dated. Sultan's pictures are complex but they do not look confused. He seems to possess an uncanny ability to find order in disorder and to balance compositional demands with the emotional nature of his subject matter. Behind all those flames he likes to paint, there lies a cool head.

DONALD SULTAN, CONTEMPORARY ART, AND POPULAR CULTURE

BY LYNNE WARREN

Donald Sultan is an artist of the 1980s. Born in 1951, he fits neatly into the demographics of the baby boom generation, raised on television and with the comforts afforded by American postwar abundance. This generation, as has been pointed out by a wide spectrum of sociologists and historians, is widely and deeply influenced by popular culture, which in the late twentieth century has taken an increasingly dominant position in American society.[1] Sultan's paintings, however, even though they are very "American" in feeling and despite the fact that they are inspired as much by newspaper current events photographs as by the great masters of art history, seem untethered from popular cultural references and have a timeless quality that sets them apart. His subject matter — lemons, steers, industrial scenes, Nocturnes, harbor scenes, cityscapes, and so on — is clearly painted out of spiritual necessity and not out of some deliberate desire to be timeless by eschewing popular culture and choosing "classical" themes. Unlike so many of his peers, Sultan seems to have escaped if not the influence of popular culture — besides being a source of subject matter through newsphotos, the media have definitely shaped his outlook on life — then its limitations. That he has managed to do this is a key both to some of the critical neglect his work has suffered in comparison to that of his contemporaries and, more important, to how his work will fare in the longer run of art history. In the late twentieth century, with art increasingly being seen as yet another victim of destructive consumer forces, fewer and fewer are looking to art for the succor it has traditionally provided — sensuous experience, emotional sustenance, and intellectual gratification. Donald Sultan's work,

because it has escaped the limitations of popular culture, offers something rarely seen today, an opportunity for a straightforward emotional experience, free from the discomforting distortions of the idiosyncratic and the particular, which have tied much of today's art to tenuous and often fleeting meanings that dissipate with the advent of each new "movement."

Popular culture's flamboyant leap into the center stage of contemporary life, partnered by the postwar reorientation of American society toward consumerism, has had a profound impact on the course of art history in the past several decades. The best-known instance of contemporary art and popular culture mixing is the movement Pop Art (roughly 1955–65). To many this movement crystallized the possibilities of a relationship between art and popular culture — that popular culture is there to be utilized by artists in a rational, analytical manner to comment on both the state of art and the state of culture. This movement featured, as John Russell and Suzi Gablik put it in their 1969 book, *Pop Art Redefined*, which accompanied an exhibition at the Hayward Gallery, London: "Images [that are] . . . part of popular culture as presented through the surrogate world of mass media . . . images from the cinema, images found in the mass media (like comic strips and billboards), food (like hamburgers and Coca-Cola) and clothing."[2]

Yet from today's standpoint, it seems the reason Pop artists were first drawn to this material was not a well-thought-out plan of attack upon cultural shortcomings[3] so much as an extremely effective means of commenting on the cult of the artist as a unique, spiritually privileged entity, that is, in countermanding the idolatry paid the Abstract Expressionists who immediately preceded them.[4] The phenomenon of artists' countering the artworld status quo as a significant factor in the development of new styles is increasingly apparent as the century progresses, with its cycles of abstraction and

figuration. The cultural implications of an art interested in the popular culture quickly came to the fore, however, and were widely discussed, with the consensus seeming to be that these references were good — opening up the elitist, leftover Renaissance conceptions of art to the realities of life in the twentieth century, with its mass communications and egalitarian tenor.[5] Popular culture per se was not given a stamp of approval, but popular culture as a *tool* for aesthetic investigation was.

The heady notions of opening up art to a broader audience continued after the heyday of Pop, yet the art of the late 1960s and 1970s, the fifteen or so years when art was centered on aesthetic issues (notably Minimalism, Conceptualism, and technological and media investigations), was generally apart from direct reference to popular culture. Yet other lessons had been learned from Pop Art aside from the desirability of appealing to a wider audience. Artists were beginning to understand that the essence of American culture had changed; art no longer was a repository for spiritual or aesthetic ideals, but was becoming yet another aspect of the consumer culture.[6] Indeed, many of the works of the Minimalist period were manufactured goods (Carl Andre's bricks; Donald Judd's boxes), mirroring in their aesthetics the concerns common to the popular culture. Even so, it was a bit of a shock to see popular cultural references appearing and in vast quantities in the art of the current generation of artists as they emerged in the early 1980s. From Cindy Sherman's poignant, media-inspired character studies, to Eric Fischl's unsettling psychosexual portraits of the middle class, to David Salle's cool portrayals of the new urban ethos, to Keith Haring's graffiti, popular culture has reigned. The unforced ease with which popular cultural references intermingled with all manner of imagery borrowed from art history, mythology, and even the bible almost seemed the unifying "theme" that tied together otherwise highly

disparate styles. What caused this great outpouring of popular cultural reference?

In 1974 Lawrence Alloway claimed of the Pop Art generation that "the mass media entered the work of art, and the whole environment was regarded, reciprocally, by the artists as art too. Younger artists did not view popular culture as relaxation, but as an ongoing part of their lives. They felt no pressure to give up the culture they'd grown up in (comics, popular music, movies)."[7]

Yet this description seems more applicable to the young artists of the current generation than to those of the Pop era. For significantly lacking in Alloway's litany of the popular cultural institutions that the young artists of the Pop era grew up with is television. The Pop artists, most of whom were born in the 1920s and 1930s, might have grown up with "comics, popular music, and movies," but they did not grow up with television. They might have felt comfortable with Pop references, but they also distinguished clearly between them and "non-Pop." The current generation of artists, most of whom were born in the 1940s and 1950s, did grow up with television;[8] seen through this lens, the world is a very different place. John McHale cogently pointed out in his essay "The Fine Arts in the Mass Media" that "watching Sir Kenneth Clark and Henry Moore discussing the Elgin marbles on television may seem an ultimate in fine arts exposure. But it depends on where you sit — otherwise it may be just another programme — in which two agreeable and cultivated TV personalities chat about some exotically lit statuary."[9]

Many found the free-and-easy use of popular cultural references repugnant; many hailed the development — which went hand-in-hand with the resurgence of figuration and the medium of painting — as vital and stimulating. Often accused of rummaging through art history, it seems instead that the television-bred generation of artists was merely featuring in their works a

method of collating and displaying information that is not dissimilar to how television gathers and displays information. John McHale's above-cited analysis is again instructive. Television is a great leveler of information. No matter what its source or original disposition, once put out over television, information becomes just another bit of the masses of information that are spread throughout the culture by the electronic medium. This is not to say there is no distinction made among various sorts of information, rather that the strict hierarchy that formerly prevailed and dictated what was suitable for "art" and what was not is broken down. Thus popular cultural references seem just as valid as any other references.

Yet in today's art world, to say the 1980s generation of artists uses popular culture merely because it is a natural part of their vocabulary is to oversimplify vastly the relationship of contemporary art and popular culture. Today's popular culture, as sophisticated and glamorous as it is,[10] is really very far removed from the ideas that currently and historically have pervaded the art world. Many of these ideas are extremely cynical.[11] This is not to say that popular culture does not display any cynicism, but the "average" person does not plumb the depth of the cynicism that has shaped Modernism, with its inherent philosophy of disrupting the status quo. Popular cultural symbols thus become very useful double-edged swords in the hands of the artists who use them. To the *cognoscenti* these symbols express the cynicism and despair of late twentieth-century life and thus they are valued; to the "average" viewer these are symbols in a vocabulary with which he is conversant. This does not mean that the mass audience automatically understands and likes contemporary art with popular cultural references — the distrust that is also inherent in the notion of Modernism[12] prevents this, but at least this audience knows what the images themselves are, the first step in setting up

communication. The fact that the young masters of today's scene are routinely commissioned to decorate nightclubs and the pages of upscale magazines is some indication of the success of the communication. Yet double-edged swords by definition cut both ways: by using popular cultural references, even as only a part of their imagery, many of today's artists seem to be limiting themselves to a narrow, essentially banal, frame of reference that will not outlive the moment of its popularity.

Fueled in large part by advertising, either directly[13] or through "concepts" originated in movies or popular music but picked up and promoted by advertising,[14] popular culture is, in its very nature, fleeting. Advertising, in order to stay effective, either changes its "sell" or repackages its product; in either case rapid change is indicated. In order for artworks to continue to have meaning to successive generations, and not become mere curiosities that capture the popular mood of the moment like so many old Coca-Cola posters or vintage cigarette ads, the imagery with which they are constructed must be timeless on some level. Ironically, the masterpieces of Pop Art seem to be surviving so well because in cogently seizing upon certain images and repeating them, they force us to remember the otherwise uninteresting, highly ephemeral popular objects and images they depict. Thus we will remember the Campbell soup can long after it has been redesigned or the romance comic strip long after it has faded from the scene because these things are the subject matter of famous works of art, rather than recalling these things for what they signified in the popular cultural context of the early 1960s.[15]

Once the notoriety of the banal into the art context had been exploited, the possibilities of this sort of transformation were exhausted. Today's artist is faced with a very different situation: with the boundaries between popular culture and art blurred, even the possibilities of energizing an image with notoriety is lost. Banal

material is likely to remain banal.

Donald Sultan, in spite of his average, middle-class upbringing during the 1950s and 1960s, seems hardly to have been a typical product of such an upbringing. His father, a successful businessman, toiled in his basement on an odd labor of love for a small-town husband and father of the era — he painted abstract paintings. Sultan's own personality was (and is) more "literary" — outgoing, intellectual, and critically oriented — rather than "artistic," which implies a solitary, introspective individual. At age eleven Sultan became involved in theater, a love of his mother's. This early orientation toward theater and acting nurtured his natural inclination to side with the nexus of creativity itself — to express creative intuitions and thoughts directly rather than to seek fulfillment through the physical processes of creating a product or a "work of art."[16] Although acting offered sustenance for Sultan's particular creative drive (he studied theater as an undergraduate at the University of North Carolina, Chapel Hill), he began to feel that acting was too limiting, for an actor must rely on many others to ply his trade; furthermore, Sultan was not comfortable with being directed. He first turned to filmmaking and then to painting. The years he spent at college, both at Chapel Hill and The School of the Art Institute of Chicago, seem to have yielded little in the sense of a pupil learning from teachers; Sultan's education seems always to have been in his own hands. He had a "feeling of painting" that arose naturally within himself. One of his prime motivations to paint was that he wanted to experience current paintings in a way that truly satisfied him as the great works of the past did, and he had not found any that provided this type of satisfaction.

Because of his particular personality, the twists and turns of both popular and high culture and their concomitant impact upon taste seem not to have molded Sultan as many of his contemporaries have been shaped. Rather than

following the tradition of the avant-garde in rejecting the prevailing sensibility, his approach has been to look carefully at and think through the various styles of art that surrounded him while maturing, learning from Abstract Expressionism, Pop Art, and Minimalism and Conceptualism, and utilizing various aspects of these movements to his own advantage. Yet his imagery is neither "appropriated" nor borrowed and used in a dense, unsympathetic way. He does not indulge in quotation for the sake of mere virtuosity; Sultan's references to other paintings are a matter of his being passionately interested in a dialogue with the continuum of painting. Thus the cityscape, the harbor, the landscape, the still life, the flower and vase with their inherent dialogues between structure and chaos, the man-made and the natural, are for Sultan subject matters through which this larger dialogue with painting can be well expressed. The fractured and frenetic vision of contemporary mass media is not referred to. One does not find in Sultan's work juxtapositions or superimpositions; the former an exhausted Surrealist ploy of developing meaning out of startling or awkward contrast, the latter originally a metaphor for the glut of information in our post-Industrial Age that often disintegrates into yet another incoherent glut of information itself. Faddish colors, contemporary graphic styles, gigantic scale, and other hallmarks of current fashion in art are eschewed.[17] Aside from the scale of the still lifes and flower paintings, which have definite references to the Pop icon, his works are deceptively "traditional" in appearance. Yet they are clearly of our times. How can one escape the limitations of popular cultural references and still make works that are cogent expressions of the current sensibility? Sultan has managed this in two ways: through adapting "camera vision," and through his skillful use of industrial and building materials.

All of Sultan's compositions are highly photographic in nature. His source materials are

indeed either newspaper photos (such as in *Poison Nocturne Jan. 31, 1985*, pl. 12, or *Firemen March 6, 1985*, pl. 14), or Polaroid snapshots he makes of still lifes he sets up in his studio (such as *Two Apricots, Two Pears and a Lemon Aug. 12, 1985*, pl. 19, or *Tulips and Vase June 2, 1986*, pl. 22). The depth of field is manipulated so that the image is focused all on one plane. The image is cropped as if by the lens of a camera. Color loses some of its natural modulation and becomes flattened and more intense. Furthermore, many compositions are reduced to bold silhouettes with the "negative" spaces defining the subject matter (such as in *Steers March 2, 1983*, pl. 4). This flip-flopping of figure/ground derives not so much from the painterly investigations of Hans Hofmann, where the push and pull of color determines the figure/ground relationship, but from the graphic aspects of film, where negative and positive are reversed. Because of this photographic derivation of Sultan's imagery, the imagery looks fresh and contemporary, although the actual subject matter is usually ordinary and familiar enough to seem very traditional. We are comfortable with the way the works appear because we are used to looking at photographs and television. Thus by utilizing the modern mode of vision but working within the most "classical" aspect of this way of seeing,[18] as opposed to the highly superimposed, quick-cut video dazzle that is currently very fashionable, Sultan's works achieve a feeling of timelessness, but with a "look" that is not antiquated or old-fashioned.

Of perhaps even greater importance is the alchemy Sultan has achieved with his materials. In the everyday use for which they are manufactured, the building materials Sultan employs — butyl roofing tar, vinyl floor tiles, pine lumber — are economically viable substitutes for the expensive traditional materials they replace — copper or clay tile roofing, terrazzo or marble flooring, fine hardwoods. Thus tarred roofs or linoleum-tiled floors are tolerated despite

their completely unaesthetic appearance because often they are as much as can be afforded. Yet in Sultan's hands, these frankly ugly materials become extraordinarily beautiful. The butyl rubber glistens, rich and black. It is sensuous and appealing, especially when contrasted with counterpoints of intense color, as in *Black Egg and Three Lemons November 26, 1985* (pl. 20). Moreover, the oily quality of this material imparts a sleekness that mimics finely varnished Old Master paintings. The vinyl tiles, laid like a skin atop the wooden substructure of the works, become a strange sort of "hide," almost organic in feeling. Skillfully exploited for its trompe-l'oeil quality, as in *Cantaloupe Pickers Oct. 1, 1983* (pl. 5), where green tile mimics a grassy field, or almost completely obliterated, as in *Polish Landscape May 15, 1985* (pl. 16), the tile remarkably is transformed into an aesthetically pleasing material. Sultan's uncanny genius for translating these materials into beautiful paintings, which perhaps arises out of his refusal to differentiate among those materials deemed suitable for artmaking by the sheer weight of tradition and those that have been explored only in the twentieth century, seems to make the art/nonart materials debate irrelevant.

Earlier in his career Sultan was often cited as displaying a uniquely American vision. As Sultan has matured, the singular "American" quality of his work has evolved. No longer is the "Americanness" chiefly expressed by the subject matter — the steers, oil pumps, and building canyons of 1979–83 (pl. 4, figs. 14 and 15). Especially with the appearance of the more traditional still lifes that developed from the stark, emblematic early lemons and the flower-and-vase paintings, the subject matter seems now to be aligned more clearly with the continuum of Western painting. It is the sensibility that remains uniquely American, yet without the limitations of the undue influence of American popular culture of the 1950s and 1960s. His works have a solitary feeling about them, as well

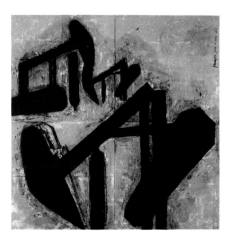

FIG. 14
Pumps July 14, 1983
Oil, latex paint, and tar
on vinyl composite tile on Masonite
243.2 × 243.8 cm (95³/₄ × 96 in.)
Private collection, New York.
Courtesy Blum Helman Gallery, New York

FIG. 15
Building Canyon June 22, 1980
Tar and vinyl composite tile on wood
31.8 × 31.1 cm (12¹/₂ × 12¹/₄ in.)
Private collection, New York

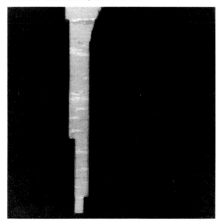

as a preoccupation with anonymity that reflects the private, individualistic character so admired in American mythology. The large lemons are almost frightening in their mute presence. Although they refer to the Pop Art icon, their painterly rendering gives them an individualistic character that humanizes and personalizes them and asks for an emotional, rather than strictly intellectual, response. Their monumentality, coupled with this moody individualism, recalls the heroic landscapes of the West, especially the works of nineteenth-century photographers such as William Henry Jackson and Timothy P. O'Sullivan. Anonymity is also central to Sultan's update of the classic theme of the equestrian portrait (fig. 2), which shows the face of the rider (who, incidentally, in a significant twist on the theme, is a woman) turned away. The harvesters in *Cantaloupe Pickers Oct. 1, 1983* are also anonymous, as are the firemen in *Firemen March 6, 1985* (pl. 14), who are shown with their backs toward the viewer. Even in the recent work *Battery May 5, 1986* (pl. 21), which features much more emotionally loaded imagery than any of Sultan's past work — a pair of lovers — the lovers are depicted in an anonymous embrace, their faces and bodies merged in a coal-black silhouette that reminds one of Edvard Munch's famous *Kiss*. Here the American penchant for individualism is shown in its dark manifestation, loneliness, where the individual is faceless in a crowd.

Sultan's Americanness is also reflected in his ability to capitalize on an image — the same talent that has proved so successful in advertising with its billboards and logos and in television, and has transformed American culture into a visually oriented ethos. Although Sultan's paintings, especially the earlier works, may seem reductive and semiabstract,[19] they are highly complex, even volatile, images, both in their formal qualities and emotional resonance. His use of the Minimalist grid in the foot-square vinyl tiles that form the ground for most of his

works, and his use of separate square panels to form his large paintings, which results in a "cross-hair" intersection at the central point of the imagery, create a great deal of tension between the subject matter and the formal devices through which the paintings are realized. This tension speaks eloquently of the visual habits of late twentieth-century man, who seems to thrive on fractured, truncated imagery. A characteristic of the current generation of artists, whose visual sense has been honed by the ceaseless, rapid-fire barrage of images put out by the media, this pictorial sophistication is one of the few traits Sultan shares with his peers; yet Sultan checks the rampant visual impulse with a healthy dose of skepticism about the efficacy of a purely visual culture. Although he does not attempt to be "literary" in his works—he is not interested in storytelling, for instance—his sensibility is analytical, his images pared down to express the most essential qualities of the experience portrayed.

Sultan's creative profile seems an odd one: a painter who does not revel in the actual physical process of painting, yet who has always created extremely sensual, painterly works; an artist who gathers information more in the way a writer gathers information, through impressions, emotions, and analysis of human behavior, yet who eschews those visual art forms conducive to such processes—language art, Conceptual art, performance.[20] His profile as a contemporary painter is even more unusual—a generational peer of the Neo-Expressionists, Sultan, without any overt stance of rejecting this style, displays in his work very few of its concerns. An informed, active New York artist who enjoys life's pleasures, Sultan nevertheless holds himself apart from fad and fashion.

It is interesting that many reviewers of Sultan's works frequently mention his undeniable success, which seems to have happened without a great deal of fanfare (by 1980s standards, that is, which often equate contemporary artists with

Hollywood actors or rock stars); his singular course through the American landscape — both literally in the subject matter he paints and figuratively in his course through the American art world — is notable. It is almost as if a talented artist's escaping the ravages of hype in the 1980s is an extraordinary phenomenon. It seems clear, however, that what Sultan has really escaped are the limitations of contemporary culture, with its undue emphasis on popular cultural reference. As Daniel Bell has written, "in [contemporary] culture, fantasy reigns almost unconstrained. The media are geared to feeding new images to people, to unsettling traditional conventions, and the highlighting of aberrant and quirky behavior . . . what has been established in the last thirty years has been the tawdry rule of fad and fashion. . . . And in the very nature of fashion, it has trivialized the culture."[21]

For an artist to be able to work successfully outside of such a quicksand of contemporary culture is a significant achievement, and Sultan is such an artist. His works are meditations on the possibilities of transcendent meaning for an audience that has forgotten, unless they have seen it via "the media," how to believe.

1. These sociologists and historians range from Daniel Bell to David M. Potter to Hannah Ahrendt, most of them agreeing that this "democratization of taste" is to the detriment of American culture.

2. John Russell and Suzi Gablik, *Pop Art Redefined* (New York: Frederick A. Praeger, 1969), p. 9. It is almost quaint from today's standpoint how the authors felt "images from the mass media" had to be explained. Indeed, the sorting out of popular culture as an entity unto itself rather than a second-class version of refined cultural taste seems to have been greatly aided by the phenomenon of Pop Art. A critical language was developed with which "Pop" was not only defined, but legitimized to a great degree by its association with "fine art."

3. That there was no "manifesto of Pop Art" seems significant.

4. Again, according to Russell and Gablik (note 2), the imagery was chosen, especially by the American Pop artists, because it "suggested the world rather than the personality" (p. 9).

5. Lawrence Alloway, "The Long Front of Culture," in Russell and Gablik (note 2), p. 41.

6. Many sociologists, most notably Daniel Bell, believe that the opening up of art to the mass audience is exactly what precipitated the decline in its significance because of its infiltration by the same hedonistic impulses that motivate popular culture. See Daniel Bell, *The Cultural Contradictions of Capitalism* (New York: Basic Books, Inc., 1976), pp. xv, 54, 86, and passim.

7. Lawrence Alloway, *American Pop Art* (New York: Collier Books, 1974), p. 7.

8. In 1949 there were fewer than one million television sets in American households; three years later in 1952, there were fifteen million sets, and in 1960, forty-six million households, or 87.1 percent of American households, had at least one television set. John E. O'Connor, ed., *American History/American Television* (New York: Frederick Ungar Publishing Company, 1983), p. xxxi.

9. John McHale, "The Fine Arts in the Mass Media," reprinted in Russell and Gablik (note 2), p. 45.

10. *Time* magazine's special "Liberty Weekend" issue to commemorate the rededication of the Statue of Liberty, entitled "America's Best," trumpeted "our national knack for the quick, the vivid, and the exuberant" in an article entitled "Pop Goes the Culture" (*Time* 127, 25 [June 16, 1986], p. 680).

11. Suzi Gablik, *Has Modernism Failed?* (New York and London: Thames and Hudson, 1984).

12. Ibid., p. 13.

13. Such as the "Teaberry shuffle" fad of the 1960s or, more recently, Cabbage Patch Kids.

14. Such as the famous Davy Crockett coonskin cap craze of the 1950s, set off by the "Disneyland" television program, or more recently, the disco dancing fad set off by the movie *Saturday Night Fever*.

15. In Andy Warhol's own oeuvre, undoubtedly his "color it yourself" works look fairly exotic and mystifying to the current generation of children who are growing up on computer graphics, with paint-by-number hobby kits all but vanished from the scene.

16. Indeed, watching Sultan work in his studio, one gets the feeling that the image exists full-blown somewhere and getting that image to appear on the canvas is not a matter of a creative frenzy but a cool, rational process. In this respect Sultan's method of working is closely aligned with the Pop, Minimal, and Conceptual sensibilities, to whom he acknowledges a debt. The image he creates, however, is *not* cool and rational, and this is where he radically departs from these artists.

17. Sultan's paintings seem huge because with their imposing physicality they command a space, yet the biggest of them are 8-by-8-feet, which is medium-size if not small by today's standards, with 10-by-16, 12-by-20-foot works routinely seen.

18. Photography has, after all, been around for 150 years, and the vision of the camera has proved to be not a passing fad, but a determinant of twentieth-century vision.

19. The only point in his career at which Sultan was seen as part of a group was in the late 1970s, when he was included in the stillborn movement "New Image," which had something to do with figurative imagery rising out of abstraction. Now it seems that Sultan's so-called "figurative ambiguity" had less to do with any great ambiguity in his paintings, and more to do with the fact that in the late 1970s, our eyes simply were unused to seeing figurative images.

20. It is interesting to note that in Chicago at The School of the Art Institute, Sultan fell in with an ambitious group of art students who were oriented primarily toward performance, language investigations, and Conceptual art. These artists founded the pioneering cooperative gallery N.A.M.E., of which Sultan was a member. His exhibitions at N.A.M.E. consisted, however, of paintings.

21. Bell (note 6), pp. xxv–xxvii.

PLATES

PL. 1
Yellow Tulip November 10, 1981
Tar, graphite, oil, and plaster
on vinyl composite tile on Masonite
250 × 123 cm (98½ × 48½ in.)
Collection Mr. and Mrs. Steven J. Ross,
New York

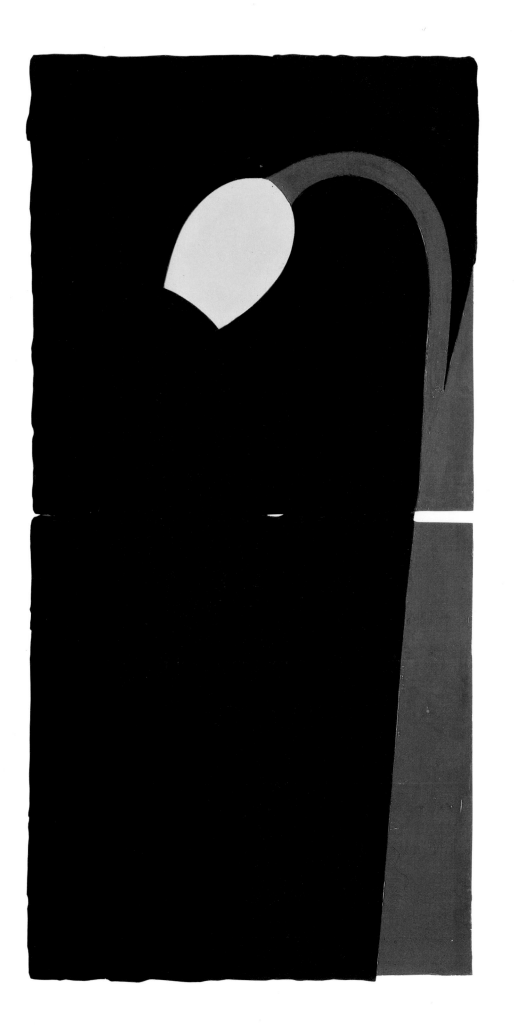

PL. 2
Smokestacks—Fire April 6, 1982
Oil, graphite, plaster, and tar
on vinyl composite tile on Masonite
244 × 122 cm (96 × 48 in.)
Collection Mr. and Mrs. Arch Cummin,
New York

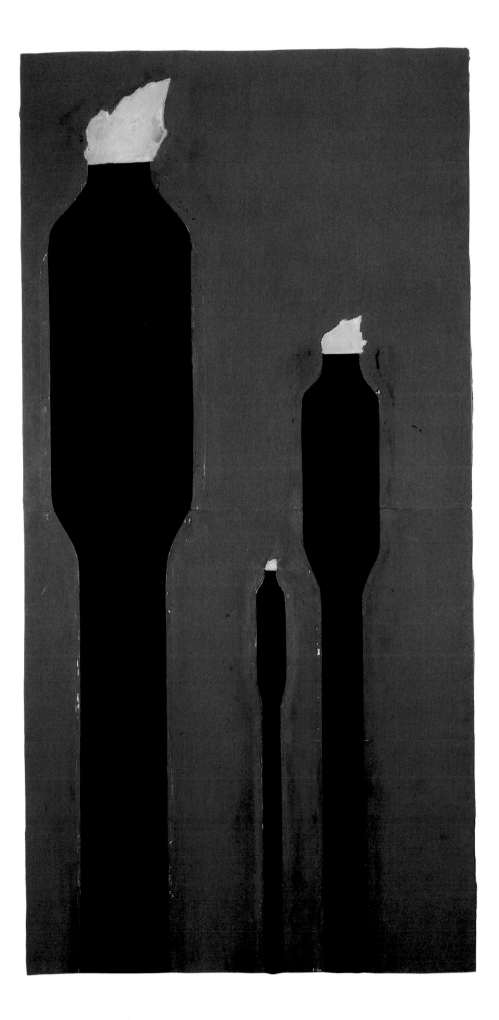

PL. 3
Cypress Trees July 20, 1982
Oil and tar on vinyl composite tile on Masonite
244 × 122 cm (96 × 48 in.)
Collection Ernie and Lynn Mieger, San Francisco

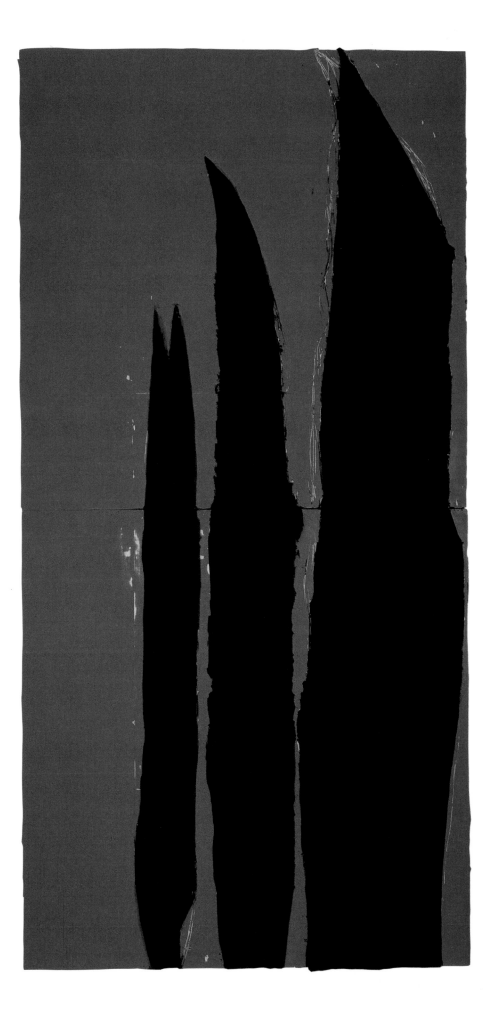

PL. 4
Steers March 2, 1983
Chalk, plaster, and tar
on vinyl composite tile
on Masonite
247 × 247 cm (97$\frac{1}{4}$ × 97$\frac{3}{8}$ in.)
Private collection, New York

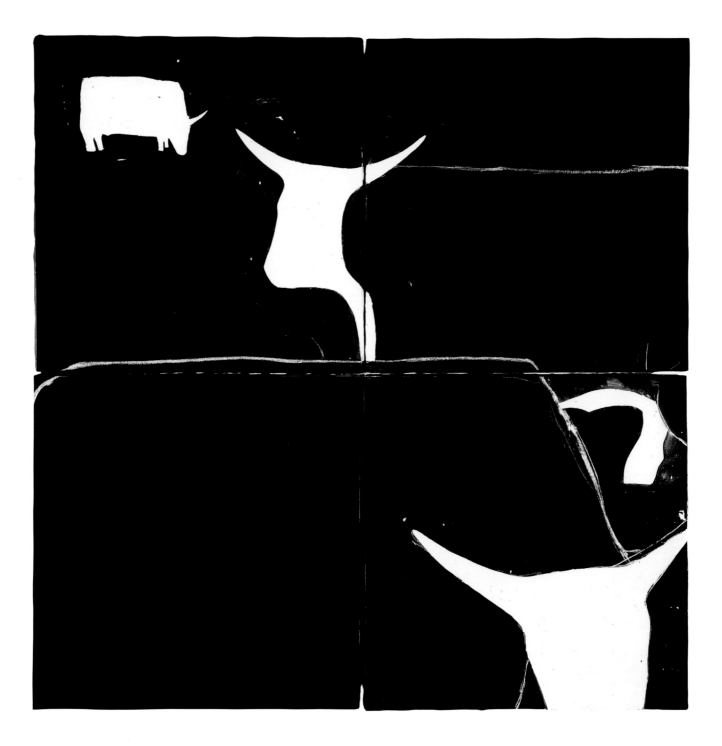

PL. 5
Cantaloupe Pickers Oct. 1, 1983
Tar and plaster on vinyl composite
tile on Masonite
244 × 244 cm (96¹/₈ × 96¹/₈ in.)
Collection Loretta and Robert K. Lifton,
New York

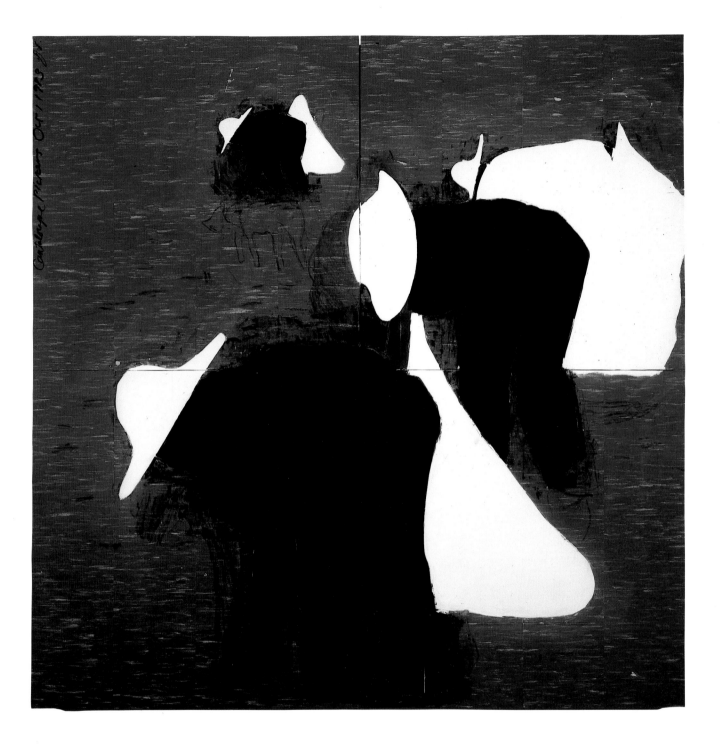

PL. 6
Forest Fire Oct. 28, 1983
Oil, watercolor, plaster,
and tar on vinyl composite
tile on Masonite
244.5 × 246 cm (96¼ × 97 in.)
Private collection, New York.
Courtesy Blum Helman Gallery, Inc.,
New York

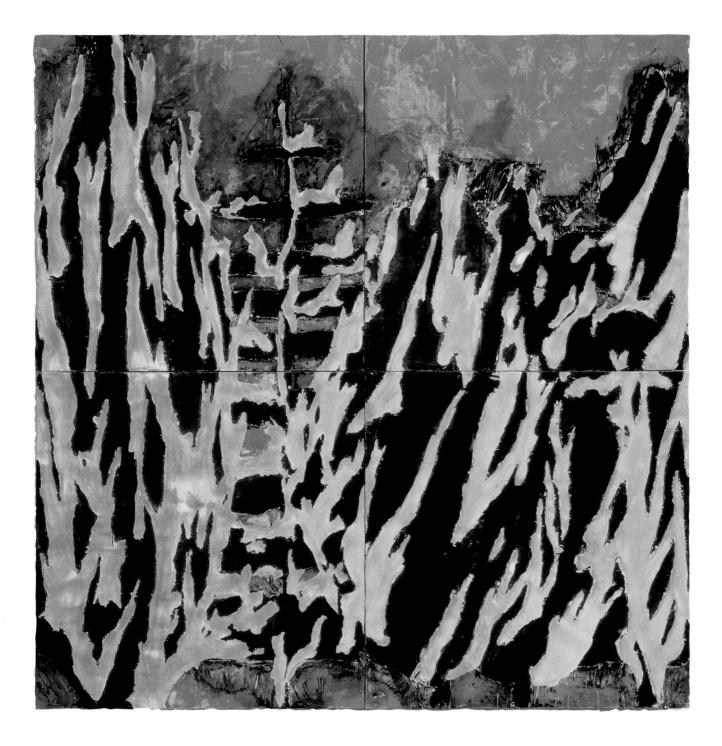

PL. 7
Lemons April 9, 1984
Oil, plaster, and tar on vinyl
composite tile on Masonite
244 × 244 cm (96 × 96 in.)
Collection Mr. and Mrs. Roger I. Davidson,
Toronto

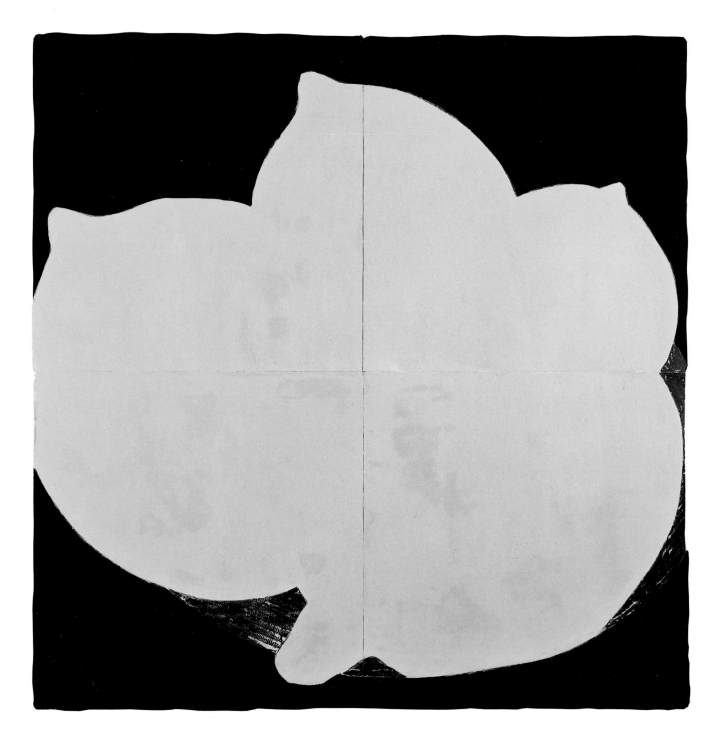

PL. 8
Lemons May 16, 1984
Tar, plaster, and oil
on vinyl composite tile
on Masonite
246 × 247.5 cm (97 × 97$^{1}/_{2}$ in.)
The Virginia Museum of Fine Arts,
Richmond.
Gift of the Sydney
and Frances Lewis Foundation

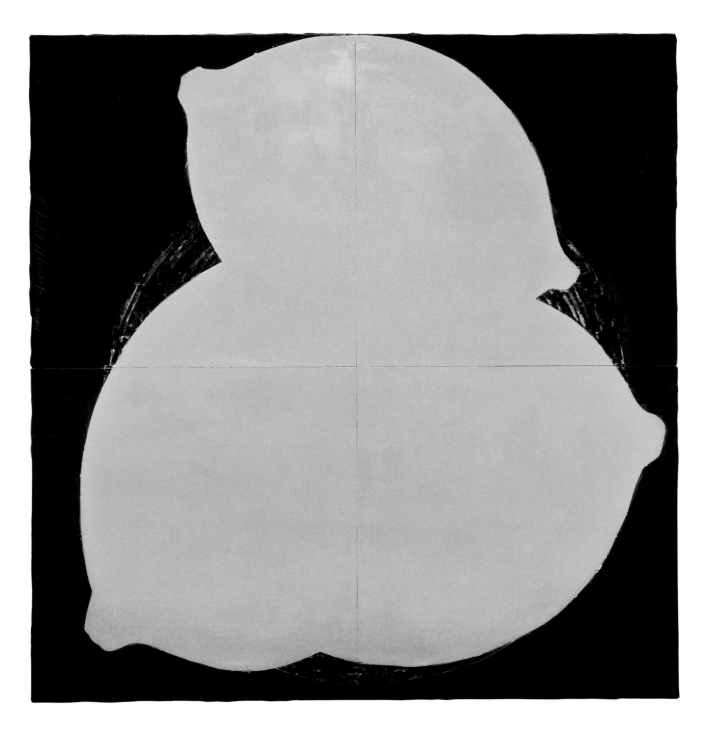

PL. 9
White Asparagus June 5, 1984
Oil, plaster, and tar on
vinyl composite tile on wood
31.8 × 31.8 cm (12^1/$_2$ × 12^1/$_2$ in.)
Private collection, New York

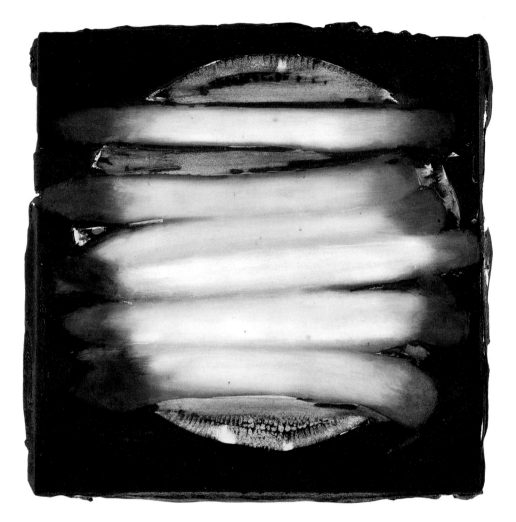

PL. 10
Harbor July 6, 1984
Tar and latex paint on vinyl
composite tile on Masonite
243.8 × 243.8 cm (96 × 96 in.)
Eli Broad Family Foundation,
Los Angeles

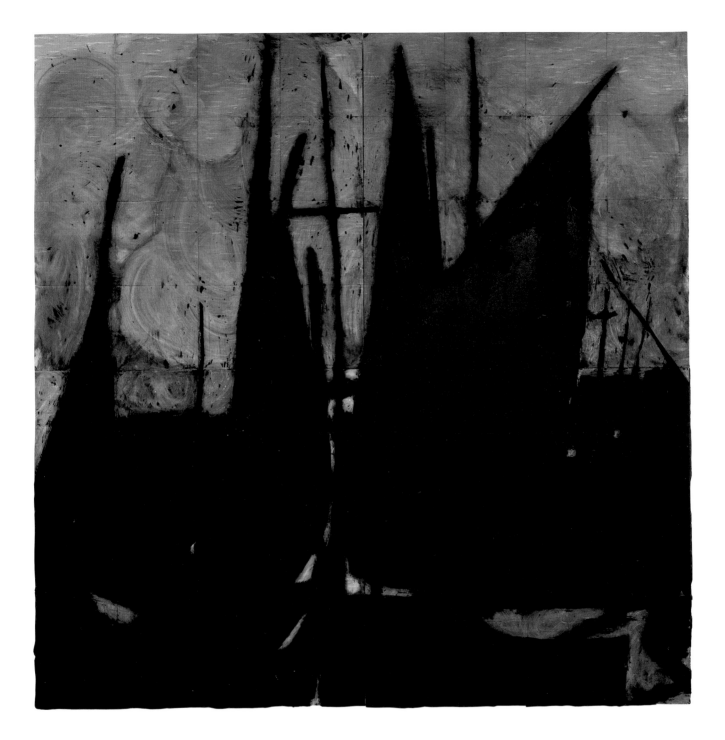

PL. 11
Pears Aug. 7, 1984
Oil, plaster, and tar
on vinyl composite tile
on wood
32.4 × 32.4 cm
(12³/₄ × 12³/₄ in.)
Private collection,
New York

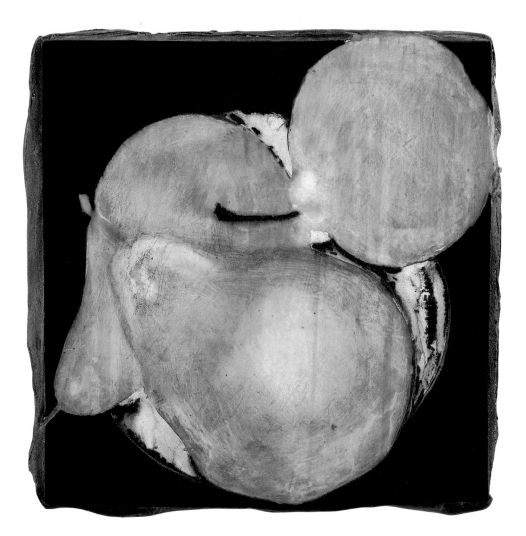

PL. 12
Poison Nocturne Jan. 31, 1985
Latex paint, plaster, and tar
on vinyl composite tile
on Masonite
245 × 245 cm (96$\frac{1}{2}$ × 96$\frac{1}{2}$ in.)
Private collection, New York

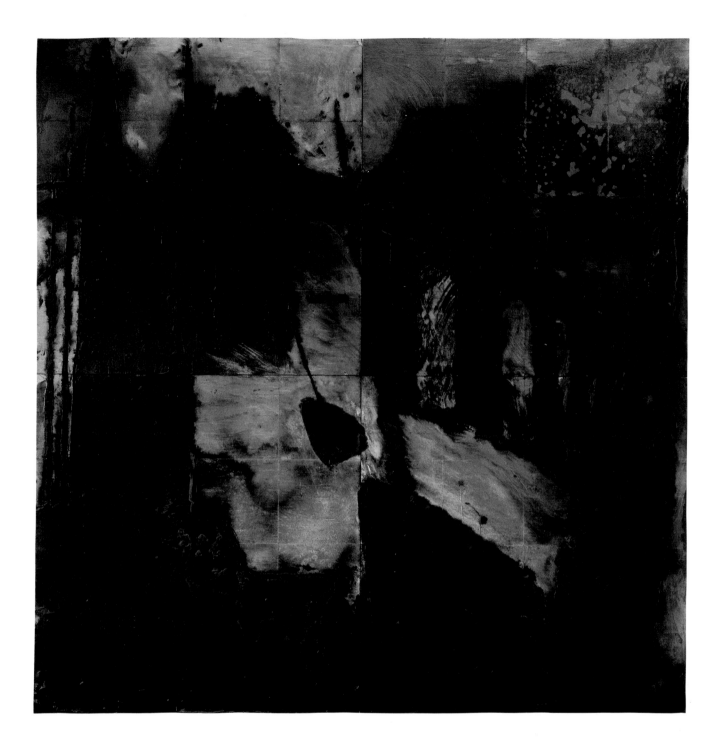

PL. 13
Two Apples, a Pear and a Lemon Feb. 21, 1985
Oil, plaster, and tar on vinyl composite tile
on wood
32.4 × 32.4 cm (12³/₄ × 12³/₄ in.)
Private collection, New York

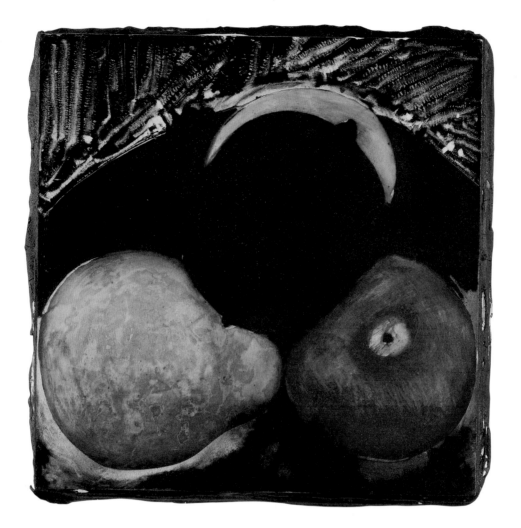

PL. 14
Firemen March 6, 1985
Latex paint and tar on vinyl
composite tile on Masonite
244 × 244 cm (96 × 96 in.)
Museum of Fine Arts, Boston.
Tompkins Collection

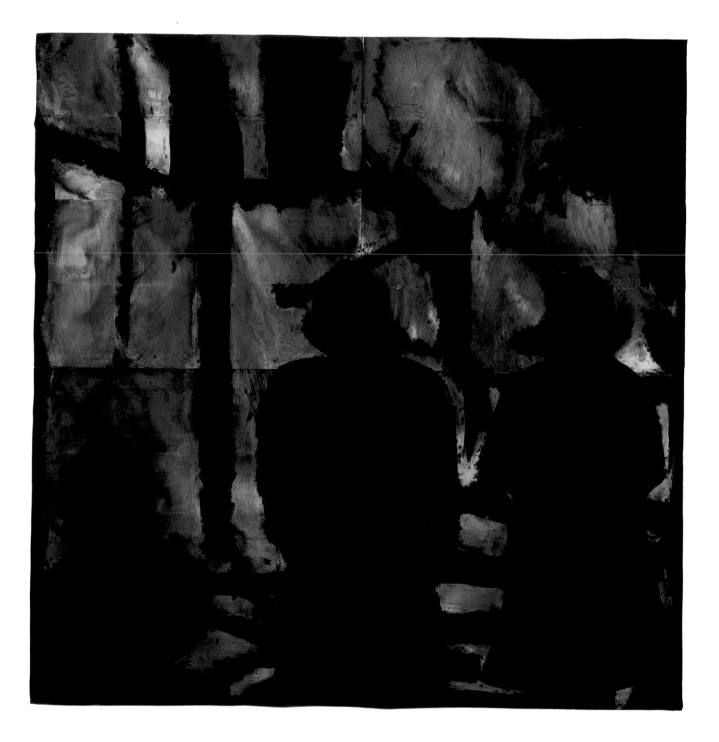

PL. 15
Four Lemons March 21, 1985
Oil, plaster, and tar on
vinyl composite tile on wood
30.5 × 31 cm (12 × 12³/₄ in.)
Collection of Ralph I. and
Helyn D. Goldenberg, Chicago

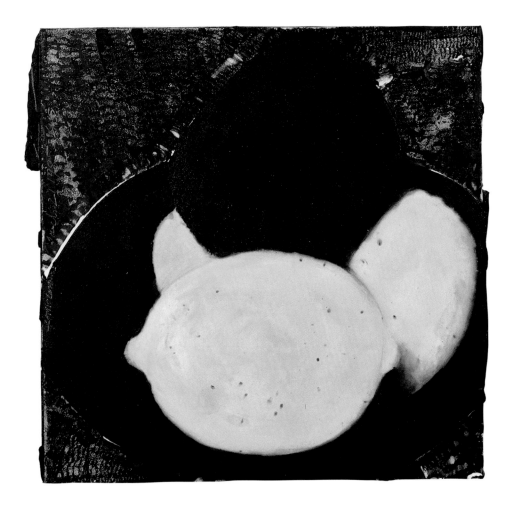

PL. 16
Polish Landscape May 15, 1985
Latex paint and tar on vinyl composite
tile on Masonite
246 × 245 cm (96⅝ × 96½ in.)
The Saint Louis Art Museum, Missouri.
Purchase: Museum Shop Fund
and Funds given by Dr. and Mrs. Alvin R. Frank,
Mr. and Mrs. George H. Schlapp,
Mrs. Francis A. Mesker, The Contemporary Art Society: Morris
Moscowitz, Mr. and Mrs. Joseph J. Pulitzer, Jr., by exchange

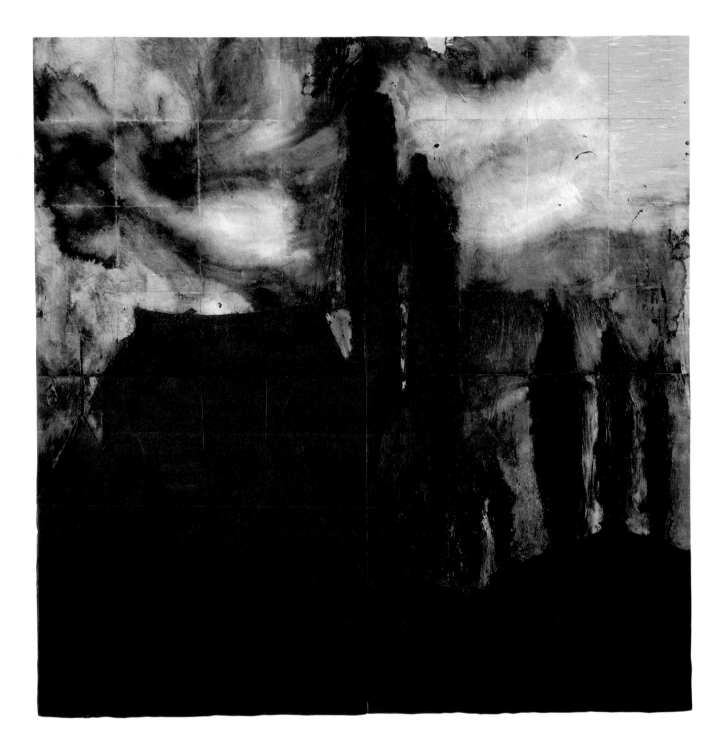

PL. 17
Plant May 29, 1985
Latex paint and tar on vinyl
composite tile on Masonite
246 × 246 cm (96³/₄ × 96³/₄ in.)
Hirshhorn Museum and Sculpture Garden,
Washington, D.C. Museum purchase with funds from
Thomas M. Evans, Jerome L. Greene,
Joseph H. Hirshhorn, and Sydney
and Frances Lewis Purchase Fund

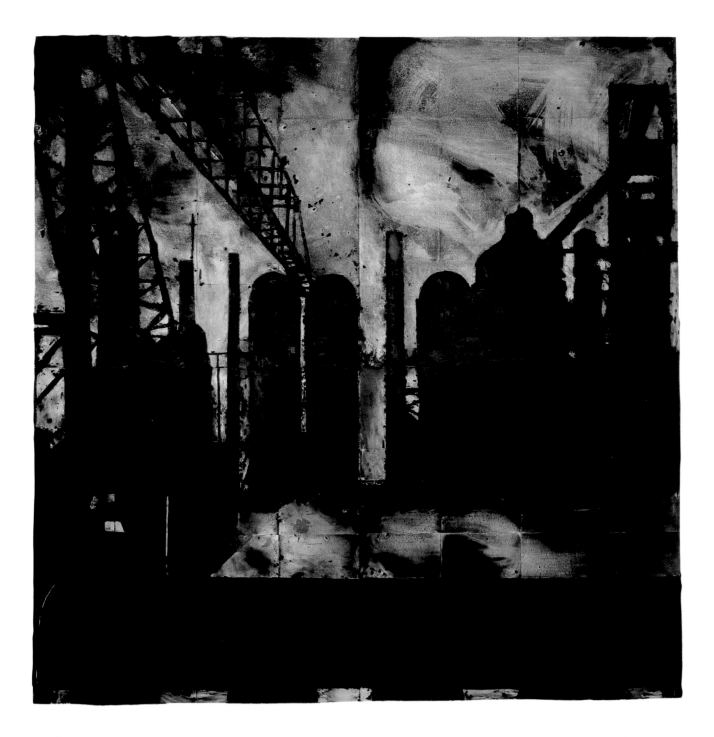

PL. 18
Two Eggs, a Lime and a Lemon June 3, 1985
Oil, plaster, and tar on vinyl composite
tile on wood
30.5 × 30.5 cm (12 × 12 in.)
Collection Mr. and Mrs. Carl D. Lobell, New York

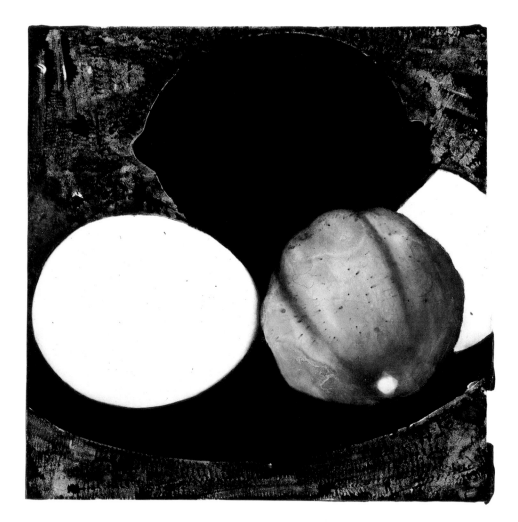

PL. 19
Two Apricots, Two Pears, and a Lemon Aug. 12, 1985
Oil, plaster, and tar on vinyl composite tile on wood
30.5 × 30.5 cm (12 × 12 in.)
Private collection, New York

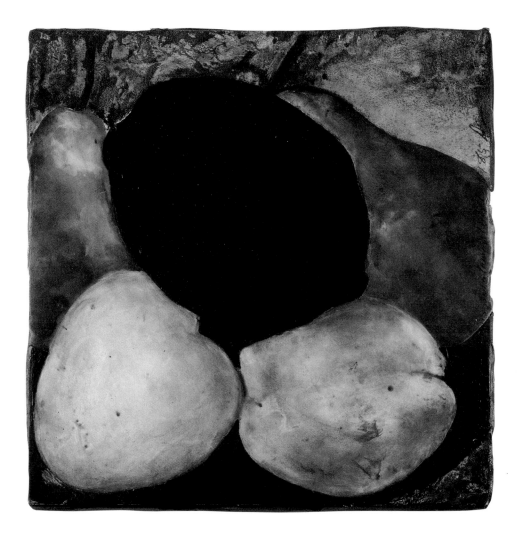

PL. 20
Black Egg and Three Lemons November 26, 1985
Oil, plaster, and tar on vinyl composite tile
on Masonite
244 × 249 cm (96 × 98 in.)
Solomon R. Guggenheim Museum, New York.
Purchased with funds contributed by
Meryl and Robert Meltzer, 1986

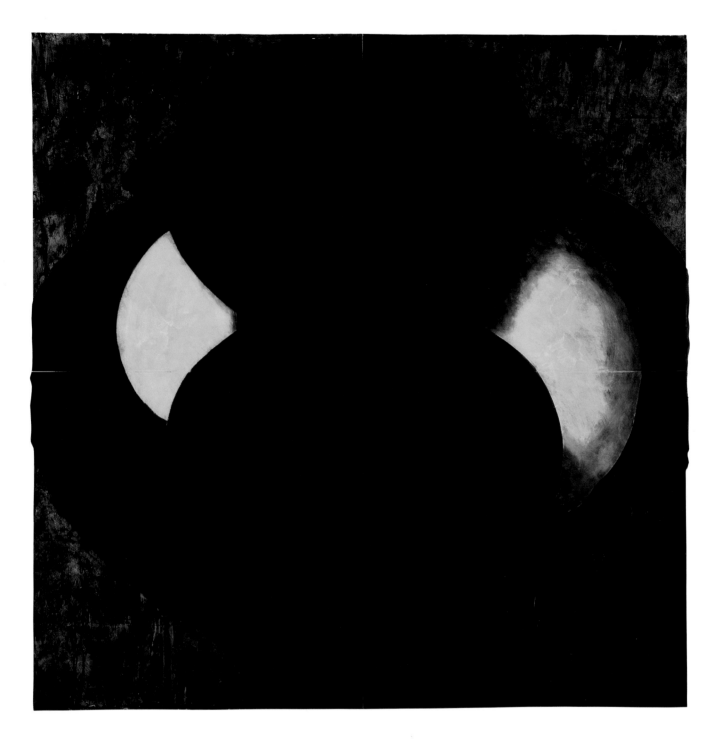

PL. 21
Battery May 5, 1986
Latex paint and tar
on vinyl composite tile
on Masonite
243.8 × 246 cm
(96 × 96⁷/₈ in.)
Collection Bill and
Barbara Street,
Tacoma, Washington

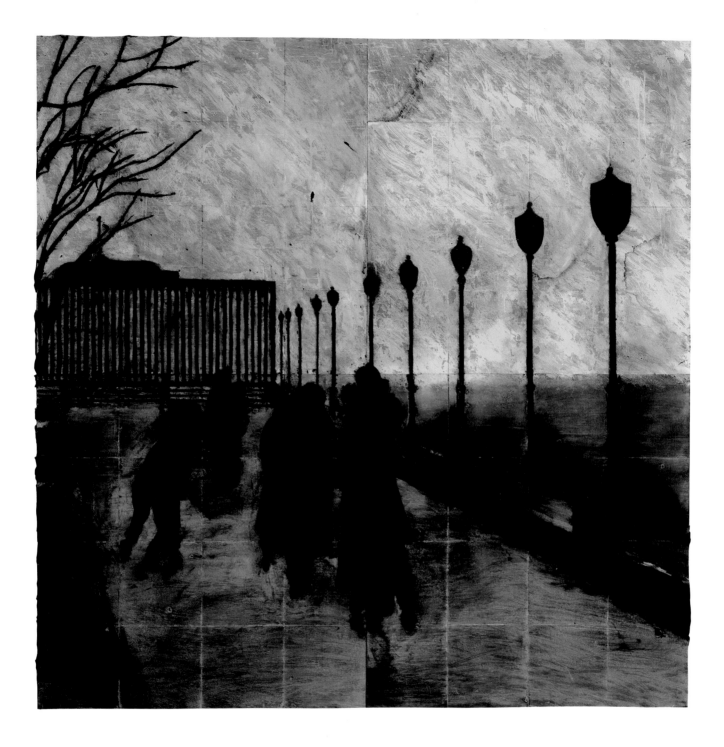

PL. 22
Tulips and Vase June 2, 1986
Oil pastel, plaster, and tar on vinyl
composite tile on Masonite
247 × 248 cm (97¼ × 97⅝ in.)
Collection Mr. and Mrs. Roger I. Davidson,
Toronto

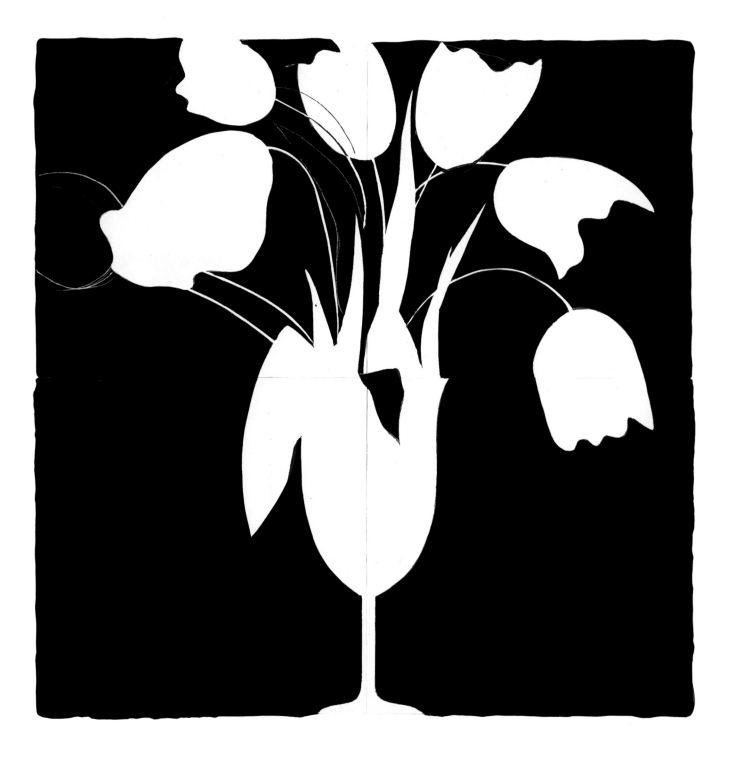

PL. 23
Black Tulip Feb. 28, 1983
Charcoal and graphite on paper
127 × 96.5 cm (50 × 38 in.)
Private collection, New York

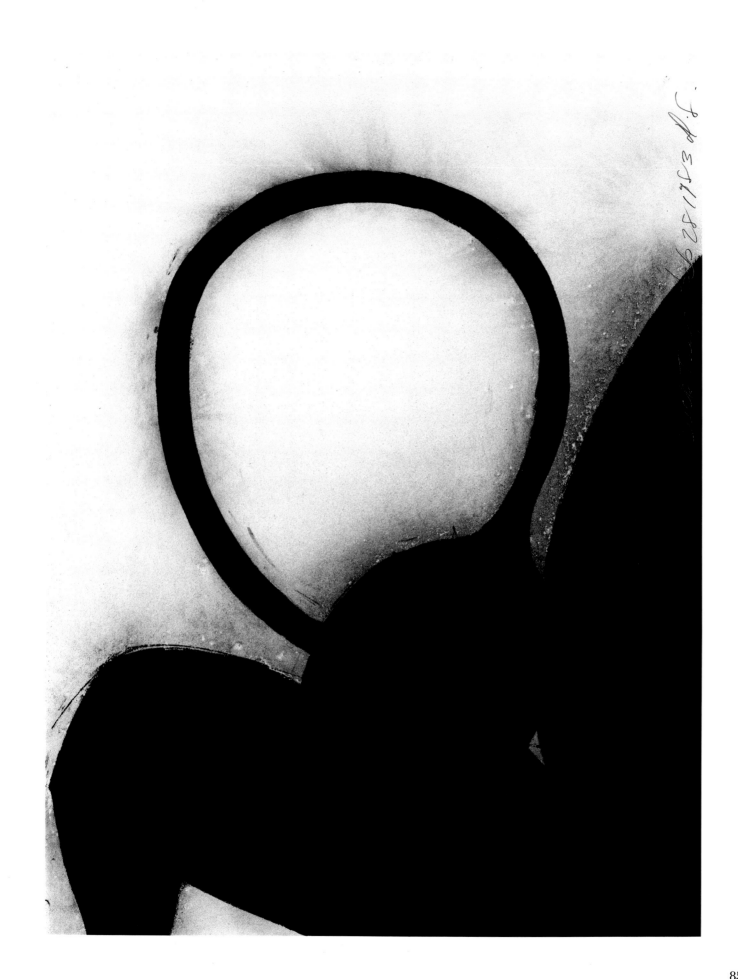

85

PL. 24
Black Tulip May 23, 1983
Charcoal and graphite on paper
127 × 96.5 cm (50 × 38 in.)
Private collection, New York

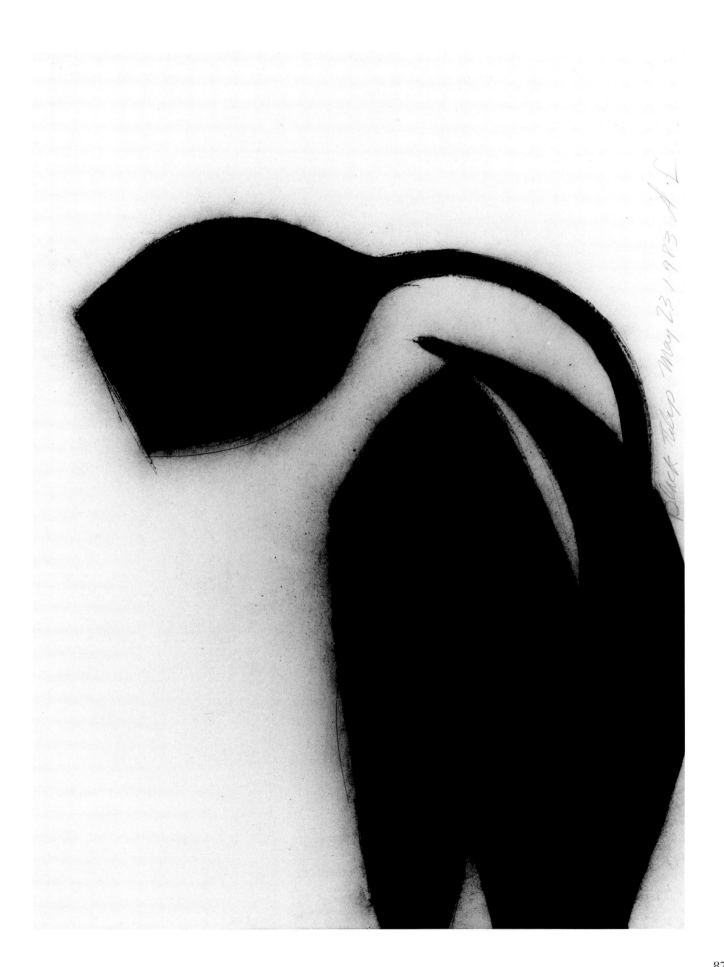

Black Tulip May 23/83 A.L.

PL. 25
Black Tulip Nov. 2, 1983
Charcoal on paper
127 × 96.5 cm (50 × 38 in.)
Private collection, Boston

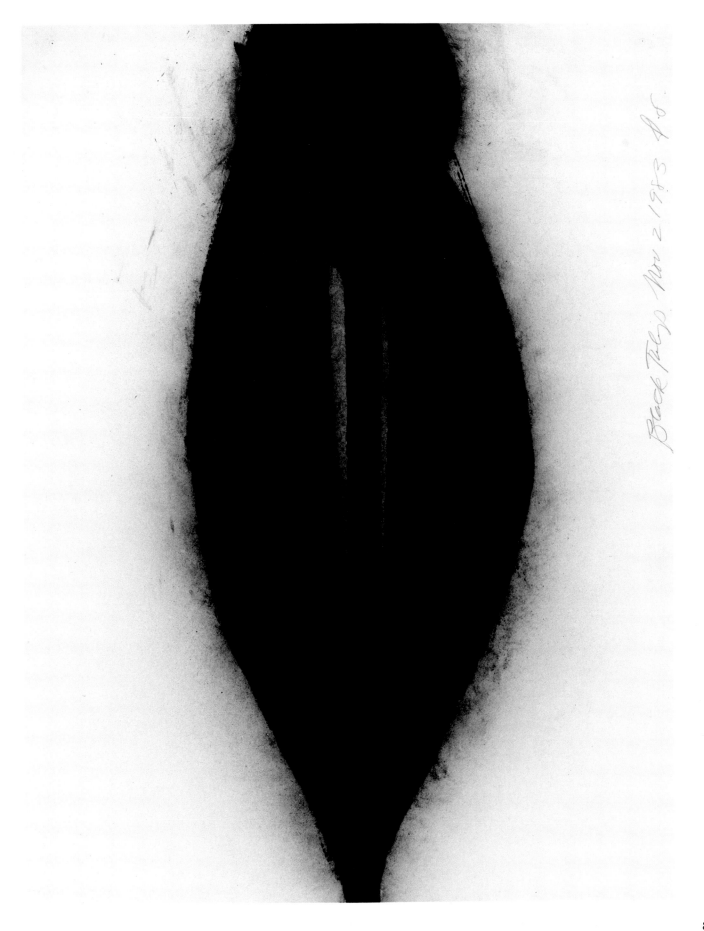

Black Tulip Nov 2 1983 A.C.

PL. 26
Black Tulip April 24, 1984
Charcoal on paper
127 × 96.5 cm (50 × 38 in.)
Collection Lynne and Howard Stacker,
St. Paul, Minnesota

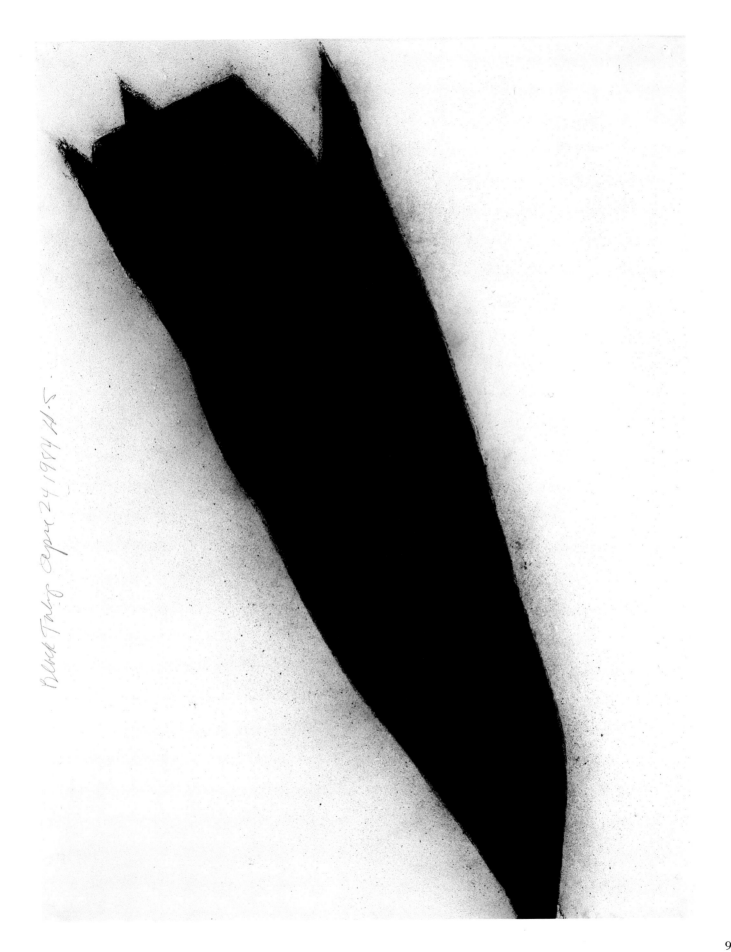

Black Tulip April 24 1984 H.S.

PL. 27
Black Lemons March 4, 1985
Charcoal on paper
127 × 96.5 cm (50 × 38 in.)
Collection Joseph Helman,
New York

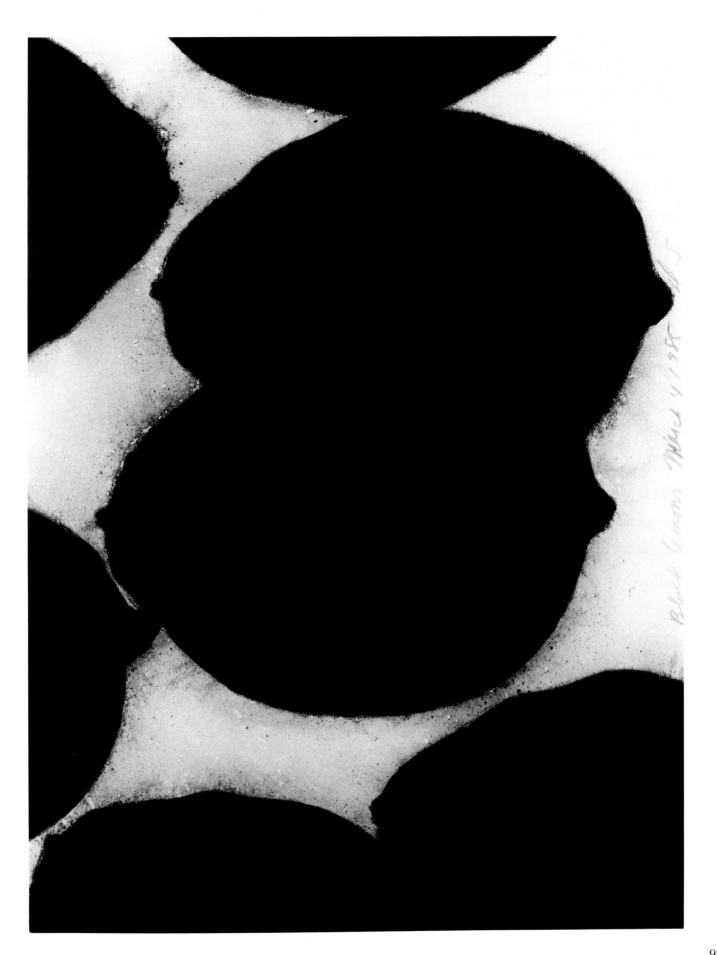

Black Unions March 4 / 1988 H.S.

PL. 28
Black Lemons Nov. 20, 1985
Charcoal on paper
152.4 × 122 cm (60 × 48 in.)
Private collection, New York

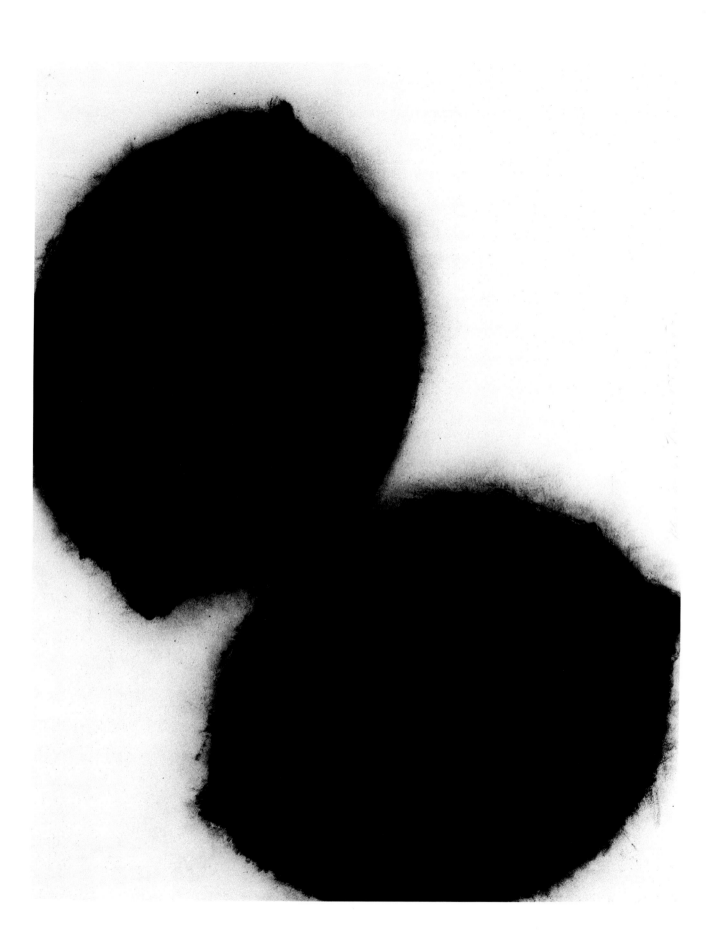

PL. 29
Black Lemons June 3, 1985
Charcoal on paper
151.8 × 116.8 cm (59¾ × 46 in.)
Collection Mr. and Mrs. Roger I. Davidson,
Toronto

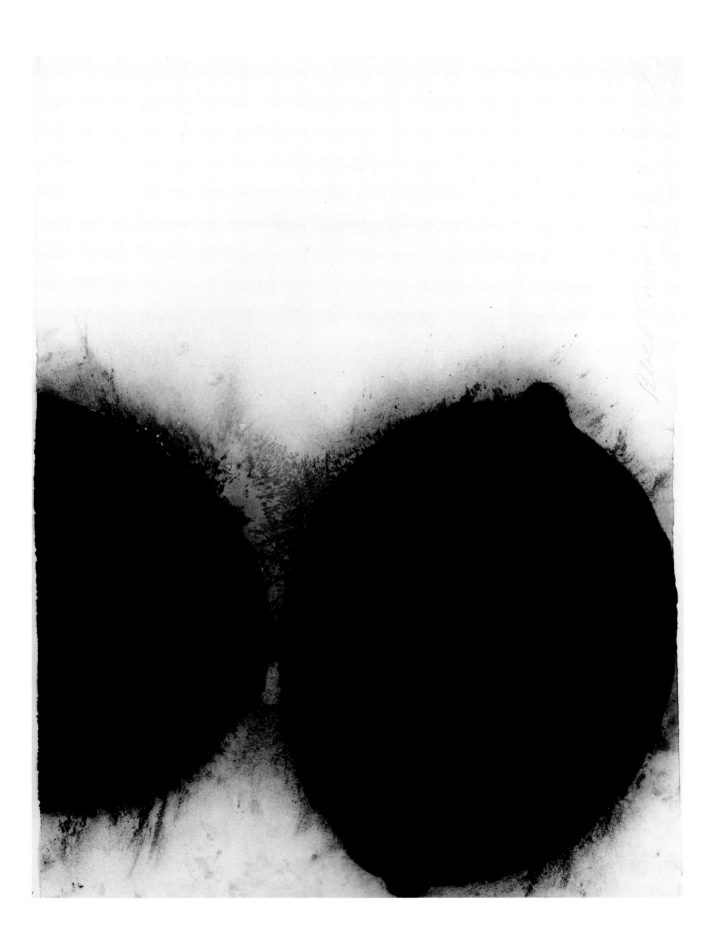

PL. 30
Lemons and Egg Jan. 21, 1986
Charcoal on paper
152.4 × 122 cm (60 × 48 in.)
Private collection, New York

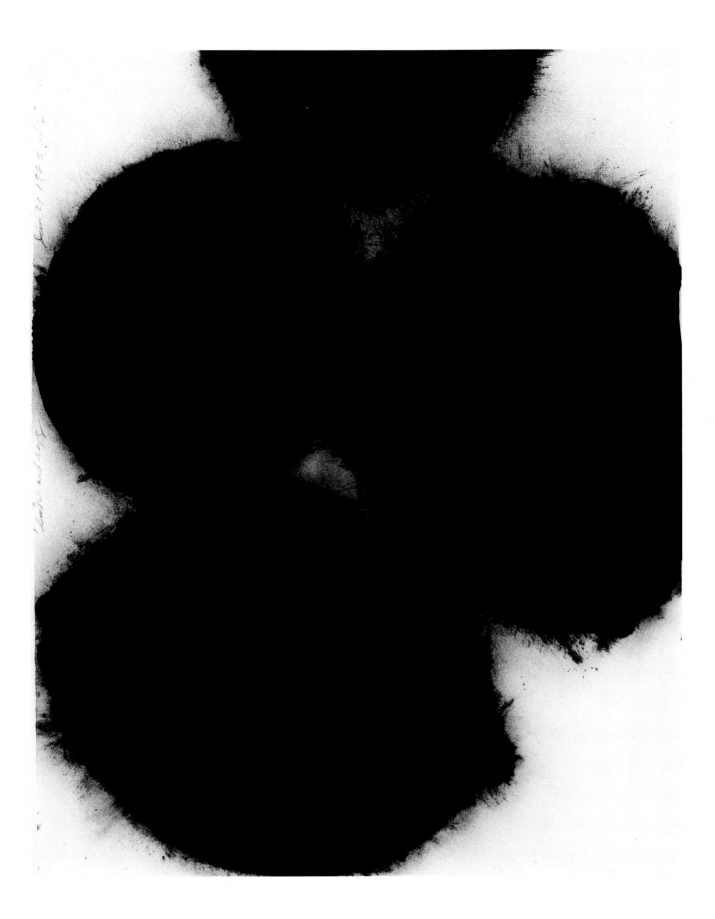

BIOGRAPHY AND LIST OF EXHIBITIONS

1951 Born in Asheville, North Carolina
1973 University of North Carolina, Chapel Hill, B.F.A.
1975 The School of the Art Institute of Chicago, M.F.A.
 Lives in New York

Selected Public Collections
 The Ackland Art Museum, University of North Carolina,
 Chapel Hill
 Addison Gallery of American Art, Andover, Massachusetts
 Albright-Knox Art Gallery, Buffalo, New York
 The Art Institute of Chicago
 Australian National Gallery, Canberra
 Dallas Museum of Fine Arts
 Des Moines Art Center, Iowa
 Fort Worth Art Museum, Texas
 The High Museum of Art, Atlanta
 The Hirshhorn Museum and Sculpture Garden,
 Washington, D.C.
 La Jolla Museum of Contemporary Art, California
 Kitakyushu City Museum of Art, Japan
 The Metropolitan Museum of Art, New York
 Museum of Fine Arts, Boston
 The Museum of Modern Art, New York
 Neuberger Museum, State University of New York,
 Purchase
 The Saint Louis Art Museum, Missouri
 San Francisco Museum of Modern Art
 Solomon R. Guggenheim Museum, New York
 The Toledo Museum of Art, Ohio
 The Virginia Museum of Fine Arts, Richmond
 Walker Art Center, Minneapolis

One-Person Exhibitions
1976 Chicago, N.A.M.E. Gallery
1977 New York, Artists Space
 Long Island City, New York, The Institute for Art and
 Urban Resources, P.S. 1, Special Projects Rooms,
 "Turning the Room Sideways"
1979 Chicago, Young Hoffman Gallery, "Donald Sultan"
 New York, Willard Gallery, "Donald Sultan"
1980 New York, Willard Gallery, "Donald Sultan"
1981 San Francisco, Daniel Weinberg Gallery, "Donald Sultan:
 Recent Paintings"
1982 Düsseldorf, Federal Republic of Germany, Hans Strelow
 Gallery, "Donald Sultan: Bilder und Zeichnungen"
 New York, Blum Helman Gallery, "Donald Sultan"
1983 Tokyo, Akira Ikeda Gallery, "Donald Sultan" (exh. cat.)
1984 New York, Blum Helman Gallery, "Donald Sultan: New
 Paintings" (exh. cat.)
1985 Boston, Barbara Krakow Gallery, "Donald Sultan Prints
 1979–1985" (exh. cat.; traveled to Georgia State
 University, Atlanta; Baxter Gallery, Portland School of
 Art, Maine; Wesleyan University, Middletown,
 Connecticut; Asheville Art Museum, North Carolina;
 California State University, Long Beach)

New York, Blum Helman Gallery, "Donald Sultan: New
Paintings" (exh. cat.)

New York, Blum Helman Gallery, "Small Paintings"

Rome, Gian Enzo Sperone, "Donald Sultan" (exh. cat.)

1986 New York, Blum Helman Gallery, "Donald Sultan:
Paintings"

New York, Blum Helman Gallery, "Donald Sultan:
Drawings"

Paris, Galerie Montenay-Delsol, "Donald Sultan"

Group Exhibitions

1972 Chapel Hill, North Carolina, The Ackland Art Museum,
"36th Annual Student Exhibition"

Charlotte, North Carolina, The Mint Museum of Art,
"Piedmont Paintings and Sculpture Exhibition"

1973 Chapel Hill, North Carolina, The Ackland Art Museum,
"37th Annual Student Exhibition"

Winston, North Carolina, The Gallery of Contemporary
Art

1974 Chicago, Wabash Transit Gallery

1975 Chicago, N.A.M.E. Gallery, "George Liebert, Donald
Sultan"

Chicago, The Art Institute of Chicago, "Graduate
Painters"

Highland Park, Illinois, Highland Park Art Center,
"Artists Invite Artists"

1976 New York, Fine Arts Building

Kansas City, Missouri, School of the Kansas City Art
Institute

1977 Chicago, Nancy Lurie Gallery

Tokyo, Institute of Contemporary Art, "Four Artists'
Drawings"

Toronto, A.C.T. Gallery

1978 New York, Mary Boone Gallery, "Group Show"

New York, The New Museum, "Doubletake"

New York, Willard Gallery, "Group Show"

Santa Barbara, California, University Art Museum,
"Contemporary Drawing/New York"

1979 Buffalo, New York, Albright-Knox Art Gallery, "Works on
Paper: Recent Acquisitions"

Chicago, Young Hoffman Gallery, "Gallery Artists"

Chicago, The Renaissance Society at the University of
Chicago, "Visionary Images" (exh. cat.)

Houston, Texas Gallery, "A to Z"

New York, Holly Solomon Gallery, "Inside/Outside"

New York, Willard Gallery, "Group Show"

New York, Whitney Museum of American Art, "1979
Biennial Exhibition" (exh. cat.)

San Francisco, Daniel Weinberg Gallery, "Bryan Hunt/
Donald Sultan"

1980 Annandale-on-Hudson, New York, Bard College, "Images"

Chicago, Young Hoffman Gallery, "Lois Lane, John
Obuck, Susan Rothenberg, Donald Sultan, John
Torreano"

Indianapolis, Indiana, Indianapolis Museum of Art,
"Painting and Sculpture Today: 1980" (exh. cat.)

Lake Placid, New York, Center for Music, Drama and
Art, "The Olympic Thirteen" (exh. cat.)

New York, Willard Gallery, "Group Show"

Providence, Rhode Island, Bell Gallery, List Art Center,
 Brown University, "Invitational"
Toronto, Yarlow-Salzman Gallery, "New Work, New York"
1981 Andover, Massachusetts, Addison Gallery of American
 Art, "New, Now, New York"
Atlanta, The High Museum of Art, "New Acquisitions"
Chicago, The Art Institute of Chicago, "New Acquisitions"
Dallas, Dallas Museum of Fine Arts, "New Acquisitions"
Houston, Contemporary Arts Museum, "The Americans:
 the Landscape" (exh. cat.)
New York, Artists Space, "35 Artists Return to Artists
 Space: A Benefit Exhibition" (exh. cat.)
New York, Blum Helman Gallery, "Bryan Hunt, Neil
 Jenney, Robert Moskowitz, Donald Sultan"
New York, The Museum of Modern Art, "Black and
 White"
New York, The Museum of Modern Art, "Prints:
 Acquisitions 1977–1981"
New York, Sidney Janis Gallery, "New Directions: A
 Corporate Collection" (exh. cat.; traveled to Museum of
 Art, Fort Lauderdale, Florida; Oklahoma Museum of
 Art, Oklahoma City; Santa Barbara Museum of Art,
 California; Grand Rapids Art Museum, Michigan;
 Madison Art Center, Wisconsin; Montgomery Museum
 of Fine Arts, Alabama)
New York, Zabriskie Gallery, "Lois Lane, John Obuck,
 Susan Rothenberg, Donald Sultan, John Torreano"
Santa Barbara, California, University Art Museum,
 "Contemporary Drawings: In Search of an Image" (exh.
 cat.)
1982 Indianapolis, Indiana, Indianapolis Museum of Art,
 "Paintings and Sculpture Today: 1982" (exh. cat.)
New York, Blum Helman Gallery, "Drawings"
Los Angeles, Margo Leavin Gallery, "Selected Prints:
 Jennifer Bartlett, Jim Dine, Jasper Johns, Elizabeth
 Murray, Donald Sultan, Robert Rauschenberg"
Potsdam, New York, Brainerd Art Gallery, State
 University College at Potsdam, "20th Anniversary
 Exhibition of the Vogel Collection" (exh. cat.; traveled
 to Gallery of Art, University of Northern Iowa, Cedar
 Rapids)
1983 Boston, Barbara Krakow Gallery, "Rare Contemporary
 Prints"
Brooklyn, New York, The Brooklyn Museum, "The
 American Artist as Printmaker" (exh. cat.)
Los Angeles, Daniel Weinberg Gallery, "Drawing
 Conclusions: A Survey of American Drawings: 1958–
 1983"
Los Angeles, Margo Leavin Gallery, "Black & White"
Madrid, Palacio de Velásquez, "Tendencias en Nueva
 York" (exh. cat.; traveled to Fundación Joan Miró,
 Barcelona, Spain; Musée de Luxembourg, Paris)
New York, Blum Helman Gallery, "Steve Keister:
 Sculpture/Donald Sultan: Charcoals"
New York, Castelli Graphics West, "Black & White: A
 Print Survey"
New York, The Museum of Modern Art, "Prints from
 Blocks — Gauguin to Now"
San Francisco, John Berggruen Gallery, "Selected Works"

San Francisco, San Francisco Museum of Modern Art, "Selections from the Permanent Collection: Graphics"

1984 Boston, Museum of Fine Arts, "Brave New Works: Recent American Painting and Drawing"

Chattanooga, Tennessee, Art and Architecture Gallery, University of Tennessee, "Images on Paper Invitational" (exh. cat.)

Chicago, Museum of Contemporary Art, "Alternative Spaces: A History in Chicago" (exh. cat.)

Kitakyushu, Japan, Kitakyushu City Museum of Art, "Painting Now" (exh. cat.)

Los Angeles, Margo Leavin Gallery, "eccentric image(s)"

Minneapolis, Walker Art Center, "Images and Impressions: Painters Who Print" (exh. cat.; traveled to the Institute of Contemporary Art, University of Pennsylvania, Philadelphia)

Montreal, Musée d'Art Contemporain, "Via New York"

New York, Blum Helman Gallery, "Drawings"

New York, Getler/Pall/Saper, "Prints, Drawings"

New York, Jeffrey Hoffeld & Company, Inc., "Little Paintings"

New York, The Museum of Modern Art, "An International Survey of Recent Painting and Sculpture" (exh. cat.)

New York, New Math Gallery, "Rediscovered Romanticism in New York City"

New York, Whitney Museum of American Art, Downtown Branch, "Metamanhattan" (exh. cat.)

San Francisco, Fuller Goldeen Gallery, "50 Artists/50 States"

Summit, New Jersey, Summit Art Center, "Contemporary Cuts"

1985 Aspen, Colorado, The Aspen Art Museum, "American Paintings 1975–1985: Selections from the Collection of Aron & Phyllis Katz" (exh. cat.)

Birmingham, Michigan, Hill Gallery, "Image & Mystery"

Boston, Thomas Segal Gallery, "Still Life"

Chicago, Museum of Contemporary Art, "Selections from the William J. Hokin Collection" (exh. cat.)

Des Moines, Iowa, Des Moines Art Center, "Iowa Collects"

Los Angeles, Daniel Weinberg Gallery, "Now & Then: A Selection of Recent and Earlier Paintings Part II"

Los Angeles, Larry Gagosian Gallery, "Actual Size: An Exhibition of Small Paintings and Sculptures"

New York, Holly Solomon Gallery, "Innovative Still Life"

New York, Joe Fawbush Editions, "Works on Paper"

1986 Brooklyn, New York, The Brooklyn Museum, "Public and Private: American Prints Today" (exh. cat.; traveled to Flint Institute of Art, Michigan; Rhode Island School of Design, Providence; Museum of Art, Carnegie Institute, Pittsburgh; Walker Art Center, Minneapolis)

Houston, Janie C. Lee Gallery, "Paintings, Sculpture, Collages and Drawings"

New York, Willard Gallery, "50th Anniversary Exhibition"

Paris, Bibliothèque Nationale, "Donald Sultan: Gravures"

Paris, Galerie Adrien Maeght, "A propos de dessin" (exh. cat.)

Youngstown, Ohio, The Butler Institute of American Art, "50th National Midyear Exhibition" (exh. cat.)

SELECTED BIBLIOGRAPHY

Articles

1975 [D.G.S.]. "Reviews: Donald Sultan at N.A.M.E." *New Art Examiner* 2, 6 (Mar. 1975), p. 11.

1976 Artner, Alan G. "Initially Speaking N.A.M.E. Spells Creative Cooperation." *Chicago Tribune*, Jan. 25, 1976.

1977 "N.A.M.E. Book I: Statements on Art." *The Soho Weekly News*, Oct. 6, 1977, p. 29.

Zimmer, William. "Don Sultan: Room 207, P.S. 1." *The Soho Weekly News*, Nov. 24, 1977, p. 48.

————. "Like the Floor of Old Kitchens." *The Soho Weekly News*, Feb. 10, 1977, p. 16.

1978 Frank, Peter. "Art." *The Village Voice*, July 3, 1978, p. 84.

Frueh, Joanna. "Book Review." *Art in America* 66, 3 (May–June 1978), p. 25.

Morgan, Stuart. "Ebb Tide: New York Chronicle." *Artscribe* 14 (1978), pp. 48–49.

Ratcliff, Carter. "New York Letter." *Art International* 22, 6 (Oct. 1978), p. 55.

Rush, David. "Contemporary Drawing—New York." *Artweek* 9, 10 (Mar. 11, 1978), p. 1.

Sloane, Harry Herbert. "For Art's Sake: Five of New York's Creative Forces." *Gentleman's Quarterly* 48, 8 (Nov. 1978), pp. 138–39.

Tatransky, Valentin. "Group Show: Mary Boone." *Arts Magazine* 53, 1 (Sept. 1978), p. 29.

1979 "Asheville Artist Holds Show in New York." *Asheville Citizen*, Oct. 28, 1979.

Frank, Peter. "Rates of Exchange." *The Village Voice*, June 18, 1979, p. 88.

————. "Where Is New York?" *Art News* 78, 9 (Nov. 1979), pp. 58–62.

Larson, Kay. "A Group Show: Willard Gallery." *The Village Voice*, Oct. 1, 1979, p. 63.

Lauterbach, Ann. "Donald Sultan at Willard." *Art in America* 67, 5 (Sept. 1979), p. 136.

McDonald, Robert. "The World Simply Seen." *Artweek* 10, 27 (Aug. 25, 1979), p. 4.

Reed, Dupuy Warwick. "Donald Sultan: Metaphor for Memory." *Arts Magazine* 53, 10 (June 1979), pp. 148–49.

Schwartz, Ellen. "Donald Sultan: Willard." *Art News* 75, 5 (May 1979), p. 170.

Zimmer, William. "Art Goes to Rock World on Fire—The Pounding of a New Wave." *The Soho Weekly News*, Sept. 27, 1979, p. 33.

————. "Building Materials." *The Soho Weekly News*, Mar. 8, 1979, p. 53.

————. "Drawn and Quartered." *The Soho Weekly News*, Jan. 18, 1979.

1980 Christiansen, Richard. "Morton Neumann: How the Hell Did I Collect It All?" *Art News* 73, 5 (May 1980), pp. 90–93.

Isaacs, Florence. "New Artists of the 80's." *Prime Time*, Dec. 1980, pp. 42–49.

Larson, Kay. "Donald Sultan at Willard." *The Village Voice*, Oct. 15, 1980, p. 103.

——. "Small Talk." *The Village Voice*, Feb. 11, 1980, p. 71.

Nye, Mason. "Donald Sultan." *The New Art Examiner* 7, 6 (Mar. 1980), p. 17.

Parks, Addison. "Donald Sultan." *Arts Magazine* 55, 4 (Dec. 1980), p. 189.

Raynor, Vivien. "Corporation Builds a Collection that Stresses Youth." *The New York Times*, Feb. 3, 1980, p. 17.

Russell, John. "Art: The Zeitgeist Signals Just Downstairs on 73rd Street." *The New York Times*, Feb. 3, 1980, p. 25.

Tolnik, Judith. "Invitational." *Art—New England*, Mar. 1980, p. 11.

Tomkins, Calvin. "The Art World: Boom." *The New Yorker* 56, 51 (Dec. 22, 1980), pp. 78–80.

Whelan, Richard. "New Editions: Donald Sultan." *Art News* 73, 4 (Mar. 1980), p. 117.

Zimmer, William. "Artbreakers: Donald Sultan." *The Soho Weekly News*, Sept. 17, 1980.

——. "Keep Up the Image." *The Soho Weekly News*, Sept. 27, 1980.

1981 Crossley, Mimi. "Review: The Americans: The Landscape." *Houston Post*, Apr. 12, 1981, p. 10AA.

Kalil, Susie. "The American Landscape—Contemporary Interpretations." *Artweek* 12, 16 (Apr. 25, 1981), p. 9.

Levin, Kim. "Donald Sultan and Lois Lane." *Flash Art* 95 (Jan.–Feb. 1981), p. 49.

Reed, Susan K. "Mort Neumann's Prophetic Eye." *Saturday Review* 81, 9 (Sept. 1981), p. 29.

Schulze, Franz. "Ree Morton's Art Winks with a Straight Face." *Chicago Sunday Sun-Times*, Apr. 5, 1981, pp. 24–25.

Tennant, Donna. "The Americans: The Landscape." *Houston Chronicle*, Apr. 26, 1981.

——. "CAM Exhibit Samples Contemporary Landscapes." *Houston Chronicle*, Apr. 16, 1981, sec. 3, p. 8.

——. "Texas Gallery Artists Attack Same Problems but Use Different Approaches." *Houston Chronicle*, Jan. 10, 1981.

Zimmer, William. "Hunter Captured by the Game." *The Soho Weekly News*, Mar. 4, 1981, p. 50.

——. "Private Properties." *The Soho Weekly News*, June 17, 1981, p. 52.

1982 Friedrichs, Yvonne. "Donald Sultan in der Galerie Strelow: Klare Profile."*Düsseldorfer Stadtpost*, Nov. 1982.

[Guiasola, Felix]. "Entrevista con Bryan Hunt y Donald Sultan." *Vardar* (Madrid), June 1982, pp. 4–8.

Henry, Gerrit. "New York Review." *Art News* 81, 7 (Sept. 1982), p. 172.

Larson, Kay. "Urban Renewal." *New York Magazine*, May 3, 1982, p. 70.

Ratcliff, Carter. "Contemporary American Art." *Flash Art* 108 (Summer 1982), pp. 32–35.

Russell, John. "Donald Sultan." *The New York Times*, Apr. 30, 1982, p. C23.

1983 Becker, Robert. "Donald Sultan with David Mamet." *Interview*, Mar. 1983, pp. 56–58.

Brody, Jaqueline. "Recent Prints." *Print Collectors Newsletter* 14, 2 (May–June 1983), pp. 63–66.

Collado, Gloria. "La experiencia neoyorkina." *Arte suplemento*, Oct. 1983, pp. 106–7.

Curtis, Kathy. "Drawn Statements." *Artweek* 14, 13 (Apr. 2, 1983), p. 3.

Glueck, Grace. "Steve Keister and Donald Sultan." *The New York Times*, Dec. 23, 1983, p. C22.

González García, Angel. "Vanguardia biológica." *El País Semanal* (Madrid), Nov. 6, 1983, pp. 141–45.

Huici, Fernando. "Las nuevas tendencias de Nueva York se exponen en el Retiro madrileño." *El País* (Madrid), Oct. 11, 1983, p. 31.

Logroño, Miguel. "Tendencias en N.Y.: Art U.S.A. 1983 en Madrid." *Diario* (Madrid), Oct. 9, 1983, p. 16.

————. "Tendencias en Nueva York." *Diario* (Madrid), Nov. 12, 1983, p. 16.

Madoff, Steven Henry. "Donald Sultan at Blum Helman." *Art in America* 71, 1 (Jan. 1983), p. 126.

Muchnic, Suzanne. "The Galleries: La Cienega Area." *Los Angeles Times*, July 8, 1983, part IV, p. 23.

————. "Survey of American Drawing 1958–1983." *Los Angeles Times*, Feb. 4, 1983, part IV, p. 16.

Ortega, Miguel. "Nada nuevo." *Guadalimar* (Madrid), Nov. 1983, pp. 13–18.

Ratcliff, Carter. "The Short Life of the Sincere Stroke." *Art in America* 71, 1 (Jan. 1983), pp. 73–79.

"Recent Prints." *Print News*, Sept.–Oct. 1983, p. 19.

Serraller, F. Calvo. "Los bellos ecos del último grito artístico." *El País* (Madrid), Oct. 15, 1983, pp. 1–2.

S., M. "Las tendencias artísticas de Nueva York irrumpen en Madrid." *A.B.C.* (Madrid), Dec. 1983, pp. 9, 45.

Soler, Jaime. "New York, New York." *Diario* (Madrid), Oct. 12, 1983, p. 19.

Willard, Marta. "El Sueño Americano." *Actual* (Paris), Nov. 7, 1983, pp. 80–82.

1984 Baele, Nancy. "N.Y. Artists Dazzle with Size." *The Citizen* (Ottawa), May 19, 1984, p. 33.

Bergeron, Ginette. "Deux Marchands de tableaux de New York." *Le Devoir*, May 19, 1984, p. 45.

Bissonnette, Else. "Via New York, un sourire." *Le Devoir*, May 28, 1984, p. 6.

Daigneault, Gilles. "Via New York: Opération réussie." *Le Devoir Culturel*, May 12, 1984, p. 32.

————. "Via New York: La Peinture des années 80 en transit à la Cité du Havre." *Le Devoir*, May 5, 1984, pp. 25, 34.

Harris, Susan A. "The Concrete and the Ephemeral: Recent Paintings by Donald Sultan." *Arts Magazine* 58, 7 (Mar. 1984), pp. 108–9.

Hearney, Eleanor. "Belief in the Possibility of Authenticity." *New Art*, Dec. 1984, pp. 118–21.

Huici, Fernando. "El Día en que Nueva York Invadió Madrid." *El País* (Madrid), Mar. 1984.

Kuspit, Donald. "Donald Sultan at Blum Helman." *Art in America* 72, 5 (May 1984), pp. 169, 178.

Larson, Kay. "Donald Sultan." *New York Magazine* 17, 9 (Feb. 27, 1984), p. 59.

Le Page, Jocelyne. "New York comme si vous y étiez." *La Presse*, May 19, 1984, p. D22.

Robinson, John. "Donald Sultan." *Arts Magazine* 58, 9 (May 1984), p. 48.

Russell, John. "American Art Gains New Energies." *The New York Times*, Aug. 19, 1984, sec. 2, pp. 1, 18.

Schwartz, Ellen. "What's New in Nueva York?" *Art News* 83, 4 (Apr. 1984), pp. 146–49.

Warren, Ron. "Donald Sultan." *Arts Magazine* 58, 8 (Apr. 1984), p. 39.

1985 Brenson, Michael. "Donald Sultan." *The New York Times*, Dec. 13, 1985, p. C32.

Cameron, Dan. "Report from Spain." *Art in America* 73, 2 (Feb. 2, 1985), p. 34.

Cohen, R.H. "New Editions." *Art News* 83, 3 (Mar. 1985), pp. 67–68.

Hughes, Robert. "Careerism and Hype Amidst the Image Haze." *Time* 125, 24 (June 17, 1985), pp. 78–83.

Raynor, Vivien. "Art: Sultan's Tar-on-Tile Technique." *The New York Times*, Apr. 12, 1985, p. C9.

Tomkins, Calvin. "Clear Painting." *The New Yorker* 61, 15 (June 3, 1985), pp. 106–13.

1986 Christov-Barkargiev, Carolyn. "Donald Sultan." *Flash Art* 128 (May–June 1986), pp. 48–50.

Edelman, Robert G. "Donald Sultan at Blum Helman." *Art in America* 74, 10 (Oct. 1986), pp. 159–60.

Henry, Gerrit. "His Prints." *The Print Collector's Newsletter* 16, 6 (Jan.–Feb. 1986), pp. 193–96.

Larson, Kay. "Donald Sultan." *New York Magazine* 19, 17 (Apr. 28, 1986), p. 97.

Mango, Lorenzo. "Donald Sultan." *Flash Art International, Edizione Italiana* 16, 6 (Jan.–Feb. 1986).

Zaya. "La técnica de alquitrán-sobre-planchas-de-vinilo viaja al S.XIV." *Hartissimo* 6 (Mar.–May 1986).

Zimmer, William. "Works by Sultan and German Expressionists at Wesleyan." *The New York Times*, sec. CN, p. 28.

Exhibition Catalogues and Books

1977 New York, The New Museum. *Four Artists: Drawings.* Texts by Marcia Tucker and Michiko Miyamoto. (New York, 1977).

1978 Santa Barbara, California, University Art Museum. *Contemporary Drawing—New York.* Text by David Rush. (Santa Barbara, 1978).

1979 Chicago, The Renaissance Society at the University of Chicago. *Visionary Images.* Text by Carter Ratcliff. (Chicago, 1979).

New York, Whitney Museum of American Art. *1979 Biennial Exhibition.* (New York, 1979).

1980 Indianapolis, Indiana. Indianapolis Museum of Art. *Painting and Sculpture Today: 1980.* Text by Robert A. Yassin. (Indianapolis, 1980).

Lake Placid, New York, Center for Music, Drama and Art. *Art at the Olympics*. Text by Tom Lawson. (Lake Placid, 1980).

1981 Atlanta, The High Museum of Art. *Recent Acquisitions: Works on Paper*. (Atlanta, 1981).

Houston, Contemporary Arts Museum. *The Americans: The Landscape*. Text by Linda Cathcart. (Houston, 1981).

New York, Artists Space. *35 Artists Return to Artists Space: A Benefit Exhibition*. Text by William Zimmer. (New York, 1981).

Princeton, New Jersey, The Commodities Corporation of America. *New Directions: Contemporary American Art*. (Princeton, 1981).

Santa Barbara, California, University Art Museum. *Contemporary Drawings: In Search of an Image*. Text by Phyllis Plous. (Santa Barbara, 1981).

1982 Indianapolis, Indiana, Indianapolis Museum of Art. *Painting and Sculpture Today: 1982*. Text by Helen Ferrulli and Robert A. Yassin. (Indianapolis, 1982).

Potsdam, New York, Brainerd Art Gallery. *20th Anniversary Exhibition of the Vogel Collection*. Text by Georgia Coopersmith and Dorothy Vogel. (Potsdam, 1982).

1983 Bernard, April. *Prayers & Sermons for a Stations of the Cross*. Ill. by Donald Sultan. (Sea Cliff, New York: Sea Cliff Press, 1983).

Brooklyn, New York, The Brooklyn Museum. *The American Artist as Printmaker*. Text by Barry Walker. (Brooklyn, 1983), p. 124.

Madrid, Ministerio de Cultura. *Tendencias en Nueva York*. Text by Carmen Giménez. (Madrid, 1983).

Tokyo, Akira Ikeda Gallery. *Donald Sultan*. Text by Maki Kuwayama. (Tokyo, 1983).

1984 *Art 83/84 — World Art Trends*. Ed. Jean-Louis Pradel. (Paris: Jacques Legrand International Publishing, 1984).

Chicago, Museum of Contemporary Art. *Alternative Spaces: A History in Chicago*. Text by Lynne Warren. (Chicago: 1984).

Kitakyushu, Japan, Kitakyushu City Museum of Art. *Painting Now*. Ed. Kyosuke Kuroiwa. (Kitakyushu, 1984).

Knoxville, Tennessee, Art and Architecture Gallery, University of Tennessee. *Images on Paper Invitational*. Text by Don Kurka. (Knoxville, 1984).

Minneapolis, Walker Art Center. *Images and Impressions: Painters Who Print*. Text by Marge Goldwater. (Minneapolis, 1984).

New Art. Ed. Phyllis Freeman et al. (New York: Harry N. Abrams, Inc., 1984).

New York, Blum Helman Gallery. *Donald Sultan*. (New York, 1984).

New York, The Museum of Modern Art, "An International Survey of Recent Painting and Sculpture." Text by Kynaston McShine. (New York, 1984).

New York, Whitney Museum of American Art, Downtown Branch. *Metamanhattan*. Text by Geoffrey Batchen. (New York, 1984).

1985 Aspen, Colorado, The Aspen Art Museum. *American Paintings 1975–85: Selections from the Collection of Aron and Phyllis Katz.* (Aspen, 1985).

Boston, Barbara Krakow Gallery. *Donald Sultan Prints 1979–1985.* Text by Ceil Friedman. (Boston, 1985).

Chicago, Museum of Contemporary Art. *Selections from the William J. Hokin Collection.* (Chicago, 1985).

New York, Blum Helman Gallery. *Donald Sultan.* (New York, 1985).

Rome, Gian Enzo Sperone. *Donald Sultan.* Text by Calvin Tomkins. (Rome, 1985).

1986 Arnason, H.H. *History of Modern Art: Painting, Sculpture, Architecture, Photography.* (New York: Harry N. Abrams, Inc., 1986).

Brooklyn, New York, The Brooklyn Museum. *Public and Private: American Prints Today — The 24th National Print Exhibition.* Text by Barry Walker. (Brooklyn, New York, 1986).

Paris, Galerie Adrien Maeght. *A propos de dessin.* Text by Frank Maubert. (Paris, 1986).

Rose, Barbara. *American Painting: The Twentieth Century.* (New York: Rizzoli International Publications, Inc., 1986).

San Francisco, John Berggruen Gallery. *John Berggruen Gallery.* (San Francisco, 1986).

Tokyo, Laforet Museum. *Correspondences.* Text by Alan Jones. (Tokyo, 1986).

Youngstown, Ohio, The Butler Institute of American Art. *50th National Midyear Exhibition.* (Youngstown, 1986).

INDEX

PHOTOGRAPHY CREDITS

David Allison, New York: figs. 1, 11, pl. 8; John Coplans, New York: frontispiece; Courtesy Blum Helman Gallery, Inc., New York: pls. 2, 3, 6, 7, 11, 20; D. James Dee, New York: fig. 4; Bill Jacobson Studio, New York: fig. 13, pls. 9, 12–14, 17–19, 21, 22, 29; David Lubarsky, New York: fig. 5, pl. 1; Andrew Moore, New York: fig. 3, pls. 16, 24–28; Musée d'Orsay, Paris: figs. 6, 7; Museo del Prado, Madrid: figs. 10, 12; Earl Ripling, New York: fig. 9; Städtische Kunsthalle, Mannheim, Federal Republic of Germany: fig. 8; Larry Thall, Chicago: pl. 15; Jerry L. Thompson, New York: fig. 2, pls. 4, 5, 10, 23; Zindman/Fremont, New York: figs. 14, 15, pl. 30.